SECRET RUTLAND

Daniel J. Codd

AMBERLEY

First published 2018

Amberley Publishing
The Hill, Stroud
Gloucestershire, GL5 4EP

www.amberley-books.com

Copyright © Daniel J. Codd, 2018

The right of Daniel J. Codd to be identified as the
Author of this work has been asserted in accordance
with the Copyrights, Designs and Patents Act 1988.

ISBN 978 1 4456 8356 0 (print)
ISBN 978 1 4456 8357 7 (ebook)

British Library Cataloguing in Publication Data.
A catalogue record for this book is available from the
British Library.

Origination by Amberley Publishing.
Printed in Great Britain.

Contents

Introduction

John Leland, a Tudor traveller and antiquarian, observed in his *Itinerary* that the county of Rutland had legendary origins. The common belief was that Rutland took its name from a fellow called Rutter – 'a man of great favour with his prince' – who was offered a reward if he could ride over as much country as possible upon a wooden horse. Rutter accepted the challenge and used 'arte magike' to accomplish the impossible feat, traversing what became Rutland's boundary. It does not seem to have ended well for him, though, because, 'he was after swallowed into ye earth'.

It is entirely possible, in fact, that 'Rutland' is derived from 'Rota's-land'. There was a high-ranking royal official between 940 and 970 in southern Mercia called Aethelstan Rota ('the Red'). Might he have been the 'Rutter' of legend?

Others claimed to know that the county became 'Rutt-land' from its deep valleys and the abrupt undulations across its landscape. Or else it developed from 'Red-land', because the rich colour of the earth gave the wool of local sheep a reddish tinge as they fed off the land. Another suggestion is that 'Rut' developed from *roet*, the old Norman Romance word for 'wheel', Rutland being perceived as vaguely circular by some.

Prior to the Norman Conquest in 1066, Rutland may have been a district rather than a county. By the time of Edward the Confessor, who died that year, it appears to have become a royal domain: he had bequeathed to his queen, Edith, 'Roteland, and all its appurtenances'. Edith Weston was probably the most westerly settlement granted to her in 'Roteland', deriving its name from its connection with her in the process. Edward had also decreed that upon Edith's death Rutland should become the property of Westminster Abbey for the rest of history.

Following the Norman invasion, William the Conqueror's Domesday survey indicates that (what is now) Rutland was partly in Northamptonshire and partly a detached portion of Nottinghamshire; while to complicate things, prior to Domesday there appear to have been connections with Stamford, Lincolnshire. (This has led to an oft-repeated belief that Stamford was once the 'capital of Rutland'.)

William the Conqueror overturned Edward's law and began to divide Rutland among himself, his relatives and powerful Norman adherents. At the beginning of the twelfth century Henry I claimed nearly the whole of Rutland, except the Alstoe Plateau, as a royal forest. However, it is generally agreed that 'Rutland-shire', as it sometimes erroneously went by in later centuries, began to emerge as a distinct county in the reign of King John. In fact, John's wife, Isabella, was the last English queen to 'own' Rutland after he gifted it to her in 1204. The king himself actually stayed in Preston four years later, on 21–22 July 1208. By the reign of Richard II, Rutland had become an earldom, governed by earls who even outranked the powerful Sheriff of Rutland, according to the seventeenth-century county historian James Wright.

The thatched cottages and twelfth-century church at Edith Weston are typical of Rutland's villages generally, and today the shaft of a medieval cross in the village's centre seems to connect us directly with those long-ago squabbles. Standing on private land north of the church there even still exists the venerable 'Domesday Oak', which has outlasted Edith Weston Hall's various incarnations. (The *Stamford Guardian* recently called this 'perhaps our equivalent of the Major Oak of Sherwood'.)

Its development aside, there is one thing above all that Rutland is today justifiably proud of – its famous status as England's smallest county. The recognition of Rutland's distinct county status is something that has taken a long time to wholly achieve, following decades of disputes over its governance. Until recently it was infamously amalgamated with Leicestershire. In 1960, following the suggestion that Rutland be absorbed into that neighbouring county, champion animals were led into the arena at the Rutland Agricultural Show, Oakham, by young people carrying placards reading, 'Rutland fights to keep local government local'. The 15,000 assembled spectators erupted in cheers. As is well known, in 1974 Rutland *was* merged into Leicestershire, which prompted a twenty-three-year campaign for the full restoration of its county status. I have been told that people staged night-time raids to take down public signs that declared Rutland towns and villages to be part of Leicestershire, and many now tell with pride how they refused to replace 'Rutland' with 'Leicestershire' on addressed envelopes they sent. This was enacted in defiance of the Post Office, and I understand this is how Braunston and Belton ended up with 'in Rutland' added to their place names – to fully distinguish them from places in Leicestershire with similar-sounding names. Therefore, as those who have seen historical newspaper accounts on the matter (such as the cuttings held within Rutland County Museum, Oakham) will appreciate, there is a justifiable sense of pride and achievement in the independence gained in 1997.

DID YOU KNOW?
Raddlemen, the term used for people from Rutland, might have developed from 'red-men', a type of pedlar who sold red stones or ochre from the Rutland earth to neighbouring farmers, for use in marking sheep in a manner less harmful to fleeces.

All visitors to the county will concede that Rutland is an attractive portion of Britain. Motorists, ramblers and cyclists are afforded magnificent views across the drystone walls and sheep-filled fields of an undulating green countryside that retains something of a look of timelessness. Roofs of roughly shaped Collyweston slate, the old-world outlines of thatch and ancient, golden villages of locally quarried pink-brown limestone are the order of the day. It sounds like a cliché, but in certain places – Ayston, for example, where there is no pavement, and even the path to the church is merely a grassy track – the modern world seems not to have intruded too much.

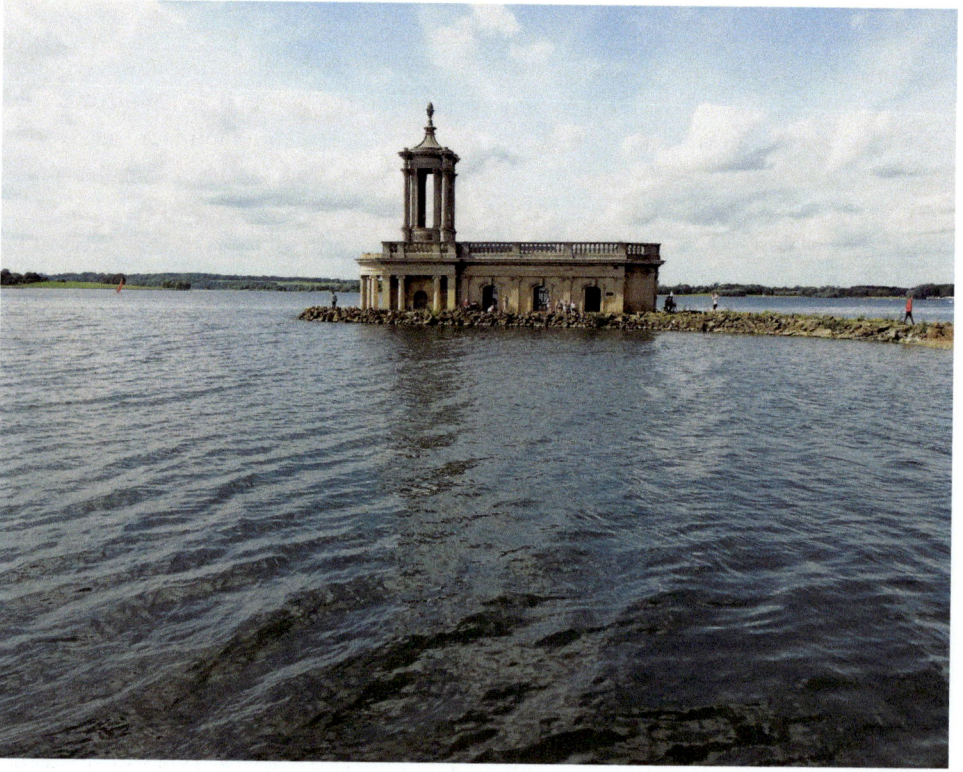

Normanton's church.

Rutland is fully landlocked and so – as if to compensate – work commenced in June 1970 on the creation of Empingham Reservoir, an immense artificial lake dominating the middle of the county, now known as Rutland Water. Today, it has become the county's most recognisable visitor attraction: a 3,100-acre expanse of water, which is one of the largest man-made lakes in Europe. This landmark is today part of the county's identity, recognised nationally for its huge pike, trout, ospreys, wildlife and conservation efforts; yet it seems strange to imagine that even as late as the 1960s it was possible to look out over a completely different landscape. It certainly must have been a distressing time if one lived in the valley as it stood on the brink of being drowned, since a number of farmsteads and the hamlets of Nether Hambleton and Middle Hambleton were all but demolished in 1975. There was, naturally, fierce opposition at the time from local farmers to this enforced change upon their way of life. A campaign against the reservoir was entitled, 'Don't flood Rutlandshire!'

To alter the topography in such a way was always bound to leave its mark in folkloric stories. I have heard it said – on more than one occasion – that to create Rutland Water 'they had to flood a village, and in doing so they submerged the church ... sometimes you can still hear the church bells chiming underneath the water.' As recently as June 2014, during a walk along the northern edge of Rutland Water, at Whitwell, I was told by a fellow visitor that she 'knew for a fact' on some occasions one could glimpse the spire

of a drowned church just below the waterline. She had heard this as a little girl from her father and believed it to be an absolute truism. This tradition has perhaps developed from an even older legend that there were once seven churches in the vicinity of Upper Hambleton, but Cromwell had six of them pulled down when attempting to take Burley House during the Civil War.

That said, St Matthew's Church, the Normanton estate's private chapel, narrowly escaped demolition and now sits – preserved, but partially submerged – on a causeway stretching out from the water's south-eastern edge, presenting an unusual landmark. Interestingly, this church, with the water now lapping at three of its sides, is itself a reminder of a previous depopulation in Rutland. In the 1760s Sir Gilbert Heathcote, 3rd Baronet, had the park enlarged by demolishing Normanton village, moving the inhabitants to Empingham and planting thousands of trees in its place. Most of the Normanton plantation is submerged now. After all that disruption, Sir Gilbert's immense Georgian country mansion, Normanton Hall, did not outlive the eradicated Normanton village by too long: by 1925 it was a burnt-out shell, and only the stabling buildings survive today in the form of the Normanton Park Hotel. St Matthew's Church only partially survived because it was considered architecturally important: the floor level was raised, and now it is a popular venue for weddings.

Old memorials to the Heathcote family can be found within St Mary's Church, Edith Weston. Interestingly, there is also a modern tablet alongside them, in memory of twenty-two people (including two rectors) whose earthly remains were removed for cremation from Normanton's St Matthew's churchyard in 1971 when work began on the Empingham Dam. The tablet was erected by the Anglian Water Authority in 1979, the year in which Rutland Water was first filled.

In this twenty-first century Rutland's fame comes from its quintessential countryside landscape, historic towns and villages, and endearing smallness. Nonetheless, the county frequently still finds itself associated with the neighbouring county of Leicestershire. Now, this is not necessarily a bad thing, but Rutland has without doubt proudly earned its own identity. Even in the smallest of places a wealth of history can be found, some of it well known, but much of it less so. It might perhaps be speculated that Rutland is too small for anything to be secret, yet Rutland is filled to the brim with its own hidden antiquities, long-abandoned settlements, intriguing locations and forgotten stories. Every parish, village and town from the Vale of Catmose to the River Welland, it seems, has something of interest to point out, and this book is a celebration of all that is Rutland.

1. Through the Eyes of History

Long-Deserted Settlements

Rutland is a county that is disproportionately dotted with the earthwork remains of centuries-old deserted settlements, mostly medieval although some are much older. For example, in 1904 the *Rutland Magazine and Historical Review* noted of Ridlington, a tiny isolated village of golden-tinted stone and thatch: 'There is evidence of three churches having once existed here, and another feature of archaeological note is the earth-work or camp lying close to the village.' These remains have been dated to the Bronze Age.

Incidentally, Ridlington's church boasts a beautifully coloured, if dusty, early seventeenth-century memorial to James Harington of Exton and his wife Frances. The village has no through road, which helps Ridlington's ancient encampment retain a reassuring feeling of undisturbed rural isolation. Similar observations could be made about many of Rutland's other deserted villages.

Prior to the Roman invasion the region was inhabited by a British tribe called the Corieltauvi, although these ancient inhabitants were subdued by Publius Osterius under the Emperor Claudius. In the aftermath of this colonisation a major Roman station developed at (what is now) Great Casterton, immediately east of Ermine Street, the main Roman route from London to Lincoln.

The remains there are thought to date to around the middle of the first century AD, beginning life as an auxiliary fort before later developing into a Romano-British settlement complete with defensive banks, ditches, kilns, a villa and possibly a bathhouse. There is a long-held belief that the town was obliterated by a marauding army of Picts and Scots who were fleeing the chieftain Hengist and his Saxon troops at Stamford. The settlement, it seems, died out around the time of the legendary King Arthur. But while the settlement had become abandoned by the fifth century, its cemetery (to the south, along Ermine Street) continued to be used until Saxon times when Earl Morcar held the manor.

Today only the grassed-over earthworks remain of this ancient Roman site – abandoned now for 1,500 years. It can be seen most clearly from Ryhall Road. Equally remarkably, twentieth-century excavations have shown Great Casterton was a Stone Age settlement long before the Romans had ever heard of these islands. In 1905, the skeleton of a Neolithic man (BC 3,000 to 2,000) was found interred at a freestone quarry in the vicinity, complete with prehistoric weapons and tools. The remains were found in clay at a depth of nearly 18 feet.

Located 10 miles to the north-west, Market Overton also had a significant Roman presence. Market Overton has for centuries been suspected of being the Roman camp referred to by the Emperor Antoninus Pius (d. 161) as Margidunum; evidencing this are the hundreds of Roman-era coins found hereabouts at various periods. In 1799, an itinerary of Antoninus's rule observed of the parish: 'Here are found Roman coins in such plenty, as but few places in these parts afford. About 300 were gathered in one little

furlong about a mile from the town.' Like Great Casterton, it may have suffered greatly at the hands of marauding Picts and Scots as they campaigned against Hengist and Horsa c. 450. The stile in the north boundary wall of the parish church is said by some to be Roman-era carved stone from the camp, although it is possibly of Anglo-Saxon origin. Either way, all agree it is impressively ancient.

A Roman town existed at Thistleton, on the Fosse Lane, where a number of Roman-era antiquities, including a well in Well Field, have been discovered. The well was on the Greetham road, which was closed when Cottesmore Airfield developed. Column sections made of Clipsham stone probably came from a temple at Thistleton and can be seen in Oakham's museum. Elsewhere, near Egleton, there used to be a circular stone shrine building situated east of Church Road. This was built by the Romans in the second century, by which time an Iron Age farmstead had already existed there for at least 200 years. One young man, aged around thirty, was of such high standing that he was actually buried within the shrine during the fifth or early sixth century – although who he was can now never be known.

In 1905 the mosaic floor of a Roman villa was exposed by a ditch digger in Grange Field, Tixover. Caldecott, too, has Roman origins. During rebuilding work at St John's Church in 1865, pieces of Roman tile were discovered in the chancel, and when the plaster was broken off the walls over the chancel arch a 2-foot square stone was revealed that had a rudely executed sculpture of two human figures in relief. It was plastered over again and today it is thought these artefacts are evidence that a Roman temple once stood on the site. Even Oakham may have Roman origins. *Leicestershire and Rutland Notes & Queries* (1891) observed, 'Oakham Castle, the real metropolis round which the little shire

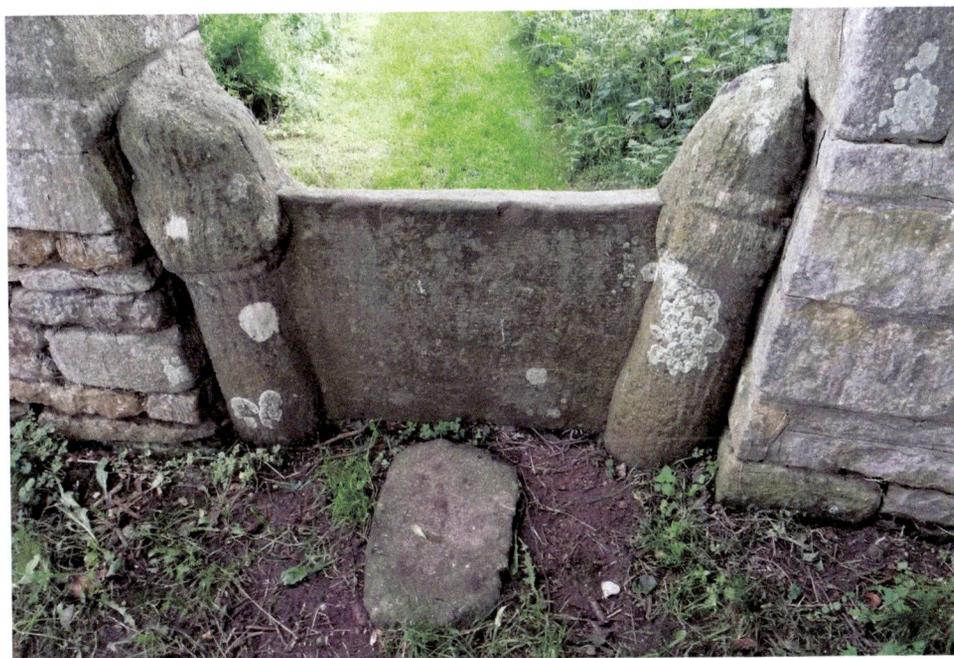

Ancient stile at Market Overton.

has always centred, still encloses the mound of an old Roman or British fortress.' At the very least, Oakham was flourishing in Anglo-Saxon times and probably derives its name from an early chieftain called Occa, with 'ham' meaning his homestead.

There are also numerous medieval settlements to be found in Rutland, mostly places abandoned through time, poverty and pasturage, which now present little more than grassy hillocks. One of the most atmospheric is Martinsthorpe, between Brooke and Manton. Martinsthorpe is a deserted medieval village –there was an attempt at post-medieval development, but the village once again suffered abandonment. Martinsthorpe Hall was pulled down in 1755, and the dilapidated chapel in 1907. The only standing building is Old Hall Farm, which has itself been uninhabited since the 1950s. The entire site is the embodiment of a deserted settlement and the views in every direction are breathtaking. Here, there is the local legend of a shepherd, Mr Branston, who lived in Martinsthorpe at some point and is said to have approached his dogs without wearing his familiar-scented greatcoat. Thinking him an intruder, they mauled him to death.

Other deserted settlements are mentioned incidentally at various points in this work, although a legend from Egleton makes one desertion perhaps more intriguing than others. Egleton is a small village today, but according to legend the population was previously much larger, with a row of cottages standing alongside the lane (locally called the Ramparts) running northwards from St Edmund's Church. In 1979 a publication by the Rutland Local History Society, *The Villages of Rutland* (Volume I, Part I), reported the belief that the village population was reduced due to an outbreak of plague in 1666. The bodies were buried in an adjacent field called Long Rotten, and the houses demolished. Today, a little eerily, if one walks northwards along Church Road a series of regular mounds in the abutting fields can be seen – sometimes suggested to be the foundations of dwellings long ago pulled down, but in reality perhaps ancient rig and furrow ploughing ridges.

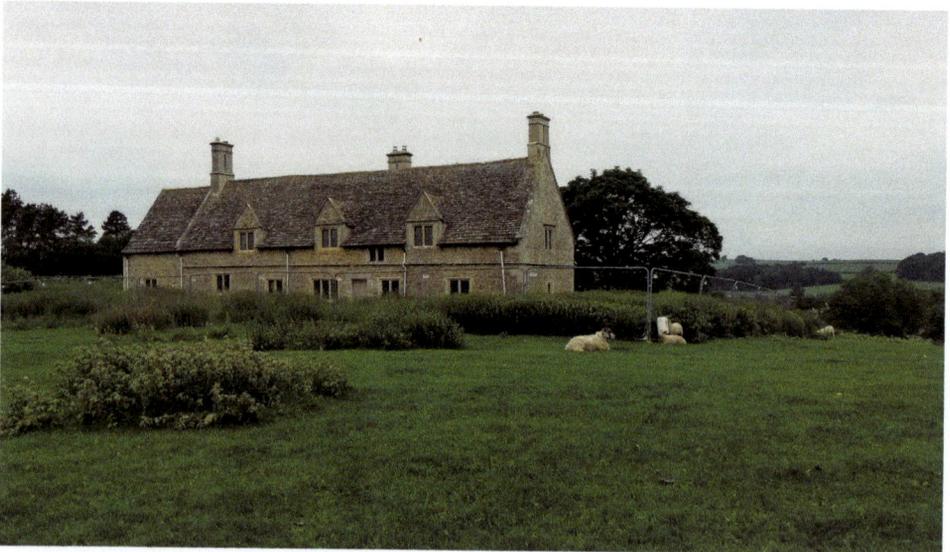

Martinsthorpe has been depopulated twice.

Rig and furrow ridges or the foundations of plague houses at Egleton?

Whether this story is true or not, other Rutland villages certainly suffered during the time of another plague in the fourteenth century. Whissendine is supposed to have become virtually decimated: a village of the dead, populated only by unburied corpses while all the dwellings stood empty. In fact, at the time rents were reduced to a bare minimum to encourage people to return to the stricken district.

There are, of course, later examples of abandoned, deserted and forgotten places. For example, Yew Tree Avenue was once part of the main carriageway to Clipsham Hall. Many of the trees are over 200 years old and from around 1880 no two adjacent ones were trimmed the same; since 2010, the avenue has become overgrown, however.

Clipsham's old limestone quarry (inaccessible to the public) is now a geological Site of Special Scientific Interest; the old Oakham to Melton Mowbray Canal closed in 1847 and has been mostly infilled, although sections of it still retain water; Manton's railway station is now a small industrial area, one of a number of county stations that fell into abandonment; and disused railway lines also snake through parts of the county. Other abandoned places we have yet to come to.

DID YOU KNOW?
The most complete skeleton of a Cetiosaurus ever found was unearthed in a quarry at Little Casterton in 1968. At 168 million years old and 15 metres long, this gigantic beast earned the nickname 'The Rutland Dinosaur'.

Yew Tree Avenue.

Lyddington Cross

Lyddington is an attractive village where many historic buildings were made from the distinctive local mellow gold-brown ironstone quarried at Stoke Dry. From Main Street, the remains of the old village market cross can be seen on an area of grassland called the Green. Standing on a rectangular base, this stone stump is believed to date to the medieval period.

In 1837 the cross was pulled down by drunken navvies who were working on the Uppingham to Caldecott road. Much of it was destroyed, although the parish constable (who was also a builder) managed to recover the stump and hide it in his yard.

For ninety-three years it was kept in Clarke's builder's yard. This was until August 1930, when it was finally re-erected in a grand ceremony organised by Dr Astley Clarke – a physician whose ancestors hailed from Lyddington and who had lately come to reside there. The cross was unveiled by a local politician, Mr Smith-Carington. As part of the event a jar containing the names of all the children at the village school was buried beneath the base with coins of the period.

Interestingly, the village school closed in 1971, but the jar containing the names of those children – from almost ninety years ago – still lies where it was placed beneath the cross. The school is now the village hall.

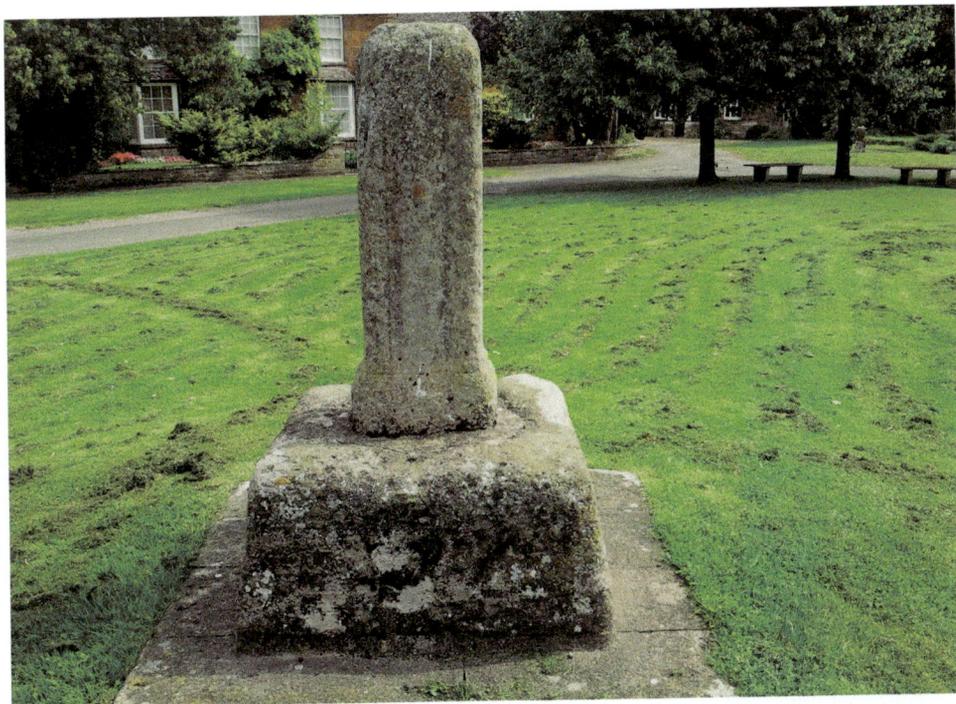

Lyddington's cross, reinstated in 1930.

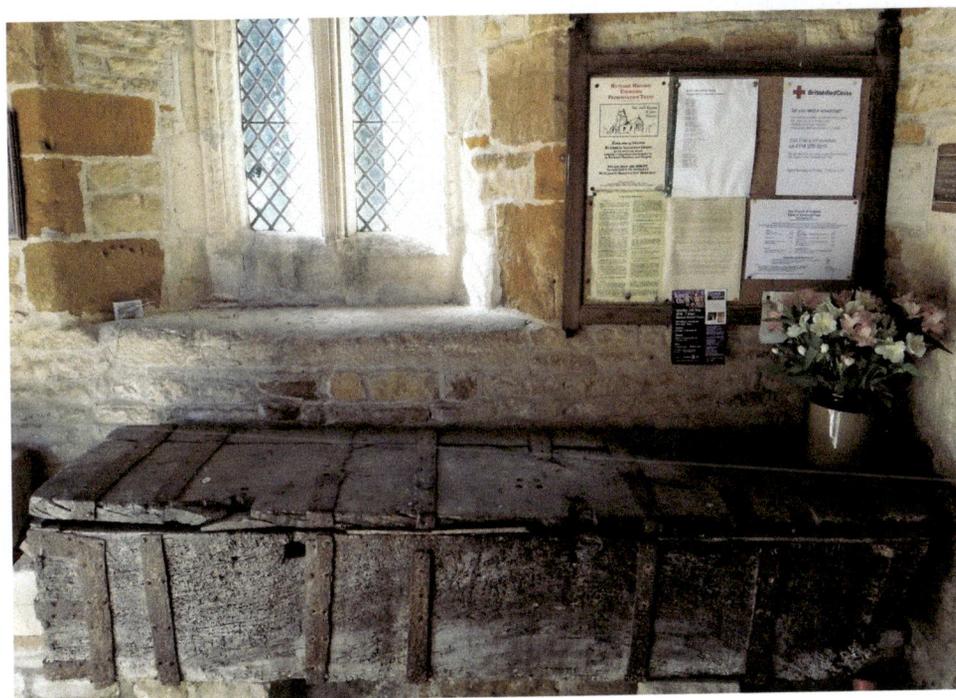

Seaton's ancient chest.

DID YOU KNOW?

Although there is probably no truth in the legend that Seaton church's ancient parish chest was left there by Richard the Lionheart for donations for the Third Crusade, it does date back to at least 1538. The chest is ironbound and very big, and was restored in 1915 – having previously been used as a chicken coop at one time!

The Lost Castles Of Rutland

Rutland is not a county readily associated with castles, although there were a number of small fortresses that once peppered the landscape – the remains of which have mostly vanished from history, save for their grassy tree-enshrouded earth mounds.

The medieval Castle of Woodhead stood between Pickworth and Great Casterton. Originally the seat of Fitzwilliam, Constable of Chester, and then the de Grelley family, it was more a manor house than a castle, although it was grand enough to host Edward I in 1290. By 1543 it was stated to be in ruins: 'The manor there hath heretofore been a proper house standing upon high ground and wholesome soil, moated round about; and the said manor house or place is now in great ruin and decay.' James Wright, the notable seventeenth-century antiquarian, implies that there had formerly been an adjacent settlement too, although by the 1680s there was 'now only one house, and that in ruins'. This 'house' was possibly the last vestige of the castle itself. Today all that is left are the waterlogged moats, an attached bailey enclosure and the fishpond. According to the *Villages of Rutland* (Vol. I, Part I) in 1979, Pickworth villagers believed that the highwayman Dick Turpin used Woodhead Castle's remains to 'hole up', and there is to this day a local legend that his ghost haunts the site.

Even less appears to be known about Beaumont Chase Castle, west of Uppingham. A post-Norman Conquest motte-and-bailey castle situated atop the slope of Castle Hill, its prominent location was described in William White's *Gazetteer of Leicestershire and Rutland* (1846): 'The most interesting object of antiquity in the parish is the *Druidical Mound* called the Castle Hill, situated near the Leicester road ... commanding, from its lofty summit, a splendid view of Deepdale and Beaumont Chase.' Although it is known that in Anglo-Saxon times the site went by the name Martin's-hoe, why White connected the location with the ancient Druids is unclear. As before, Beaumont Chase Castle may not have been a castle in the truest sense of the word; although it was possibly built for defence by Hasculf, Keeper of the Forest of Rutland, during the Anarchy of King Stephen's time. (Rutland is said to have been much more densely forested in those days, but great swathes of woodland were laid waste during Stephen's disastrous reign.) A tale exists that treasure is buried on Castle Hill. In 1911, there was an intention to take explosives to the site and open it up; however, prior to commencing, some of the dynamite accidentally ignited. Afterwards it was decided to abandon the venture, it perhaps being the belief that this was a supernatural 'warning' to discontinue.

Essendine Castle's earthworks sit behind the church.

Judging by the earthwork remains behind St Mary Magdalene's Church, Essendine Castle must have at one time been an impressive structure. Like Beaumont Chase Castle, it may have been a fortified manor house thrown up around the reign of King Stephen, possibly by the de Bussey family. The lords of the manor resided at Essendine for several centuries (there is a record of its park being raided in 1318) and the castle seems to have been functioning as late as the time of Elizabeth I, when it was inherited by Robert Cecil, the Secretary of State and Lord High Treasurer. There is a tale that Oliver Cromwell later had the castle obliterated by cannon fire during the Civil War, and these days its only inhabitants are the sheep that wander its contours. The church was the castle's chapel. It is an amalgamation of many periods and now stands within the circuits of the outer moat. (The original parish church stood a quarter of a mile away, although nothing remains of it now except a medieval window inserted in a cottage wall.)

Then there was Burley Castle, otherwise called Mount Alstoe, the mound of which can be seen by the roadside between Burley and Cottesmore. The mound has been dated to the twelfth century, again during the unsettled reign of Stephen. This was another small motte-and-bailey structure, and archaeological excavations in the 1930s suggested it was moated with a tower protected by wooden palisading. Furthermore, it may not have been fully completed, functioning as a temporary fortress during those dangerous times. The building was complimented by an accompanying village, Alsthorpe, which vanished from the historical records in 1616.

The excavations in the mid-1930s were conducted by Gerald C. Dunning of the London Museum under the auspices of the Rutland Archaeological Society. He later stated his

opinion that Burley Castle may have started off as a Saxon moot, giving it even older origins; however, of the lost village of Alsthorpe, there were no new clues as to its exact site. On the opposite side of the road, however, is Chapel Farm, which may be so called from a legend that Alsthorpe's church formerly sat on the same spot.

Around Oakham

Oakham, the jewel in Rutland's crown, has enough history sitting alongside its modern shops to easily encourage revisiting. Flore's House, which may have begun life as the home of a group of priests in the thirteenth century, and now houses the Rutland Toys and Dance Boutique, looms impressively on High Street. A blue plaque announces it to have been the residence of Roger Flore, Speaker of the House of Commons to 1422. Further up the road, another blue plaque announces an attractive thatched cottage to have been the home of Jeffrey Hudson, the famous royal court dwarf and 'smallest man from the smallest county in England, 1619–1682'. That he was served up in a cold pie to entertain visiting royalty at Burley-on-the-Hill is surely one of Rutland's most familiar stories.

In the well-preserved market square, within sight of the prestigious Oakham School complex (founded in 1584), sits the ancient Butter Cross. Also known as the Market Cross, where dairy products were sold at Oakham Market, it was depicted on Speed's map of 1611 and may have served as a preaching cross also. Some among the thousands who pass this way daily might ponder why the ancient stocks underneath the landmark only have

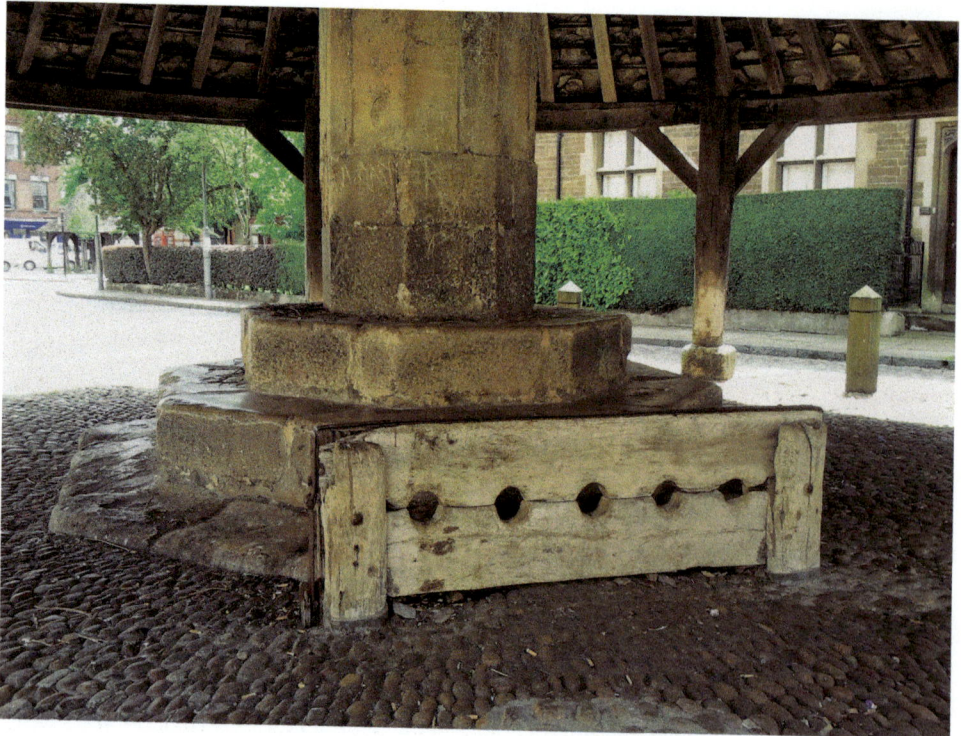

Oakham's five-holed stocks.

enough holes for two-and-a-half sets of legs. There is a story that the stocks were built with a one-legged troublemaker in mind, to worry him into better behaviour. There also used to be a whipping post there, with the last recorded public whipping being carried out in 1790 on two men who stole wood from Sir Gilbert Heathcote, of Normanton. In 1953, J. & A. E. Stokes's *Just Rutland* commented on the 'unconscious humour' of a 'NO PARKING' sign beside the stocks; it is a testament to Oakham that an old sign (probably the same one) is still situated under the Butter Cross roof.

Another attraction in Oakham is the parish church of All Saints, which contains a list of vicars dating back to 1227 and many fine stone carvings atop the nave aisles. These include a fourteenth-century depiction of Adam and Eve's expulsion from the Garden of Eden, two imps pulling faces at all visitors, Reynaud the Fox and a remarkable Green Man. The church spire's weathervane ('Cock Peter') has watched over the town since *c.* 1400. The old Oakham schoolhouse, where classes were originally taught, stands in the churchyard with the date '1584' etched on its wall. (Archdeacon Robert Johnson founded the school. He was interred at North Luffenham in 1625, where a wall brass outlines his achievements, including the erection of 'a faire free Gramar schoole' in Oakham, as well as the one in Uppingham.)

In the vicinity of South Street there once stood the Hospital of St John and St Anne, founded *c.* 1398 by William Dalby, a merchant of Exton. Most of the almshouses and warden's house have disappeared, although the original chapel remains, adjacent to a late twentieth-century retirement home development between the railway line and

Oakham's Old School, in the parish churchyard, bears the scratches of eighteenth-century graffiti on its western side.

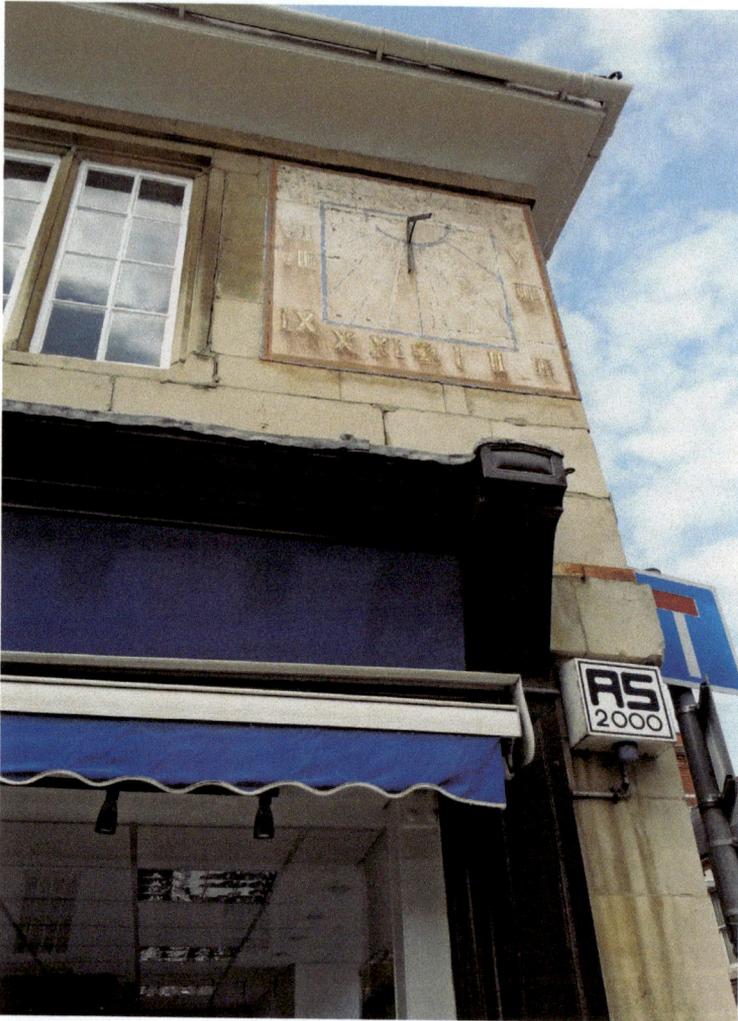

The elements
have taken
their toll on this
nineteenth-century
sundial.

New Street. Back in the town centre a Victorian sundial, now much weathered, graces a
building on the corner of High Street and Market Street, which was put there by Charles
Matkin on the premises of his printing business.

And on Catmos Street the fascinating Rutland County Museum can be found, which
opened in 1969.

The Forgotten Origins of Oakham Castle's Famous Tradition

All of which leads us, naturally, to Oakham Castle's remains. It is here that one of the
most famous traditions in the kingdom is still practised, and although it is well known, it
is the origins that stay something of a secret.

The only genuine castle remains that Rutland can boast of are those found here. But
even in its time, the castle would have presented itself as more of a giant fortified manor
house rather than the 'traditional' image of a castle. Nonetheless, it possessed many of the

features we expect of castles: a curtain wall, a gatehouse and a drawbridge lowered by iron chains, as well as (possibly) defensive towers and a moat. Cutts Close Park, with its play area and bandstand, was formerly the fishponds and garden area of Oakham Castle. The castle is believed to have been established in the late twelfth century by a Norman baron, Walchelin de Ferriers; but by 1521 the castle was in a ruinous condition, with the exception of the hall, since the courts were held there. These days all that survives of Oakham Castle is this grandiose Great Hall, although restoration and excavation work in 2015 revealed (for the first time in 150 years) portions of the castle's splendid curtain wall. Investigations to find out more about the castle are ongoing. At the time of writing, work has begun on an archaeological dig opening up a trench between the castle and the church. There has also been a second trench opened up in the field to study the foundations of an unknown building that TV's archaeological *Time Team* found in 2012 – they thought it might have been a stable block.

The Great Hall, otherwise the Shire Hall, is justifiably recognised as an outstanding example of surviving domestic Norman architecture, where banquets and assizes were held for centuries. G. Phillips's *Rutland* (1912) recorded: 'Assizes are held twice a year, when both civil and criminal business (if any) is transacted. Quarter Sessions are held four times a year, the President being the Chairman of the Magistrates. Petty Sessions are held monthly.' Even today, a Crown Court is held there every two years. The last one occurred on 27 October 2017, using the court furnishings situated within. As an incidental point of interest, I also understand from the castle's activity manager that medieval marks scratched on the columns are believed to have been protection against evil spirits and witchcraft.

The rest of the time visitors can gaze upon what is perhaps the county's most famous custom. The hall's interior walls are literally bedecked with the strangest 'wallpaper' you will ever see: horseshoes of every conceivable age, shape and size, although there is only ever one of each type, rather than four.

This décor is striking and baffling when first observed; however, an entry in Crosby's 1815 *Complete Pocket Gazetteer of England and Wales* neatly summarizes the tradition. It observes:

A whimsical custom is still kept up here, which is of some antiquity, *viz.* that the first time any peer of the realm comes within the precincts of the lordship, he forfeits a shoe from the horse on which he rides to the lord of the manor, unless he [pay instead of] the shoe, with money, and it is worthy of notice that several horse shoes, some of them gilded and of curious workmanship, are nailed on the castle door, stamped with the names of the donors, and made very large, in proportion to the sum given by way of fine.

In short, a horseshoe had to be delivered over by noble visitors to the town, or else a monetary fine was imposed on the visitor. The custom is well known, but the real secret here is its origin. It was noted as far back as 1684, when the famed Rutland antiquarian James Wright made these observations: 'The true *original* of [the] *custome* I have not been able on my utmost endeavour, to discover.' However, he did note horseshoes dating back to 1602 and 'some more *antient*, whose inscriptions are now hardly legible'.

Oakham Castle's Great Hall.

Until at least the nineteenth century this display was kept on the hall's great door, but at some point all the horseshoes were brought inside. Some of the horseshoes that cover the hall's interior walls have been symbolically presented by the highest in the land: from the Duke of Wellington and Queen Victoria to our current Queen, Elizabeth II, who supplied a navy blue horseshoe in 1967. If the tradition is carried on by the younger generation of royals then one day soon the Duke and Duchess of Cambridge may be visiting Oakham Castle. In fact, so familiar is the custom nowadays that a horseshoe actually features on Oakham's town sign. One of the most recent horseshoes was presented by *Time Team*.

The institute has in itself generated a wealth of folklore. Some say Elizabeth I inadvertently began the tradition when her horse cast one of its shoes as she rode through Oakham on her way to see Lord Burghley in Stamford. According to *Folklore, Myths and Legends of Britain* (Reader's Digest, 1973), 'There are some 220 (horseshoes) in the castle; the oldest, dated 1600, is said to have been given by Elizabeth I. The biggest, from George IV, cost £20 to make, and the king left his host to pay for it.'

In reality the tradition appears to be older than Elizabethan, however. In 1521, when it was recorded that the castle was in a ruinous state, it was also written that 'many horse shoes be set upon the hall door, some marvellous great, some little'. The record observes that one horseshoe 'was commanded thither by King Edward the fourth', possibly making the custom at least contemporary with the Battle of Empingham fifty years previously. (One of the largest horseshoes in the room is now officially designated as having been delivered at that time.)

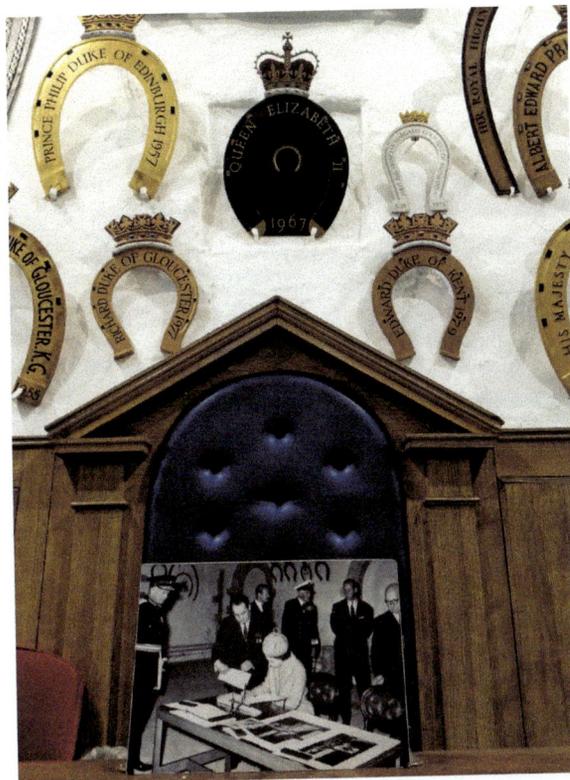

Elizabeth II presented the castle with a horseshoe in 1967.

The tradition may even have originated with the castle's founder, Walchelin de Ferriers, whose ancestral coat of arms was embellished with three horseshoes. In 1188, de Ferriers was fined heavily for a duel that arose from 'a robbery which was ill kept in his court'. Might this have been an attempt by him to forcibly take a fine in lieu of a horseshoe not being presented?

Bizarrely, this custom seems to have replicated itself in the hamlet of Burley. There is at least one (private) dwelling there adorned with multiple ancient-looking horseshoes, all hung points down in the same manner as at Oakham.

Fire, Flood and Earthquake

On the afternoon of Sunday 30 September 1750, around 12.45 p.m., an earthquake rumbled its way through Rutland. It caused such terror that the congregation in All Saints' Church, Oakham, fled the building, fearing it would collapse upon them. Some were so shocked by the event that they swooned dead away. Many will no doubt recall the series of earth tremors that rattled Rutland in 2014 and 2015. The author recalls being told at the time, during a worrying conversation in Oakham, that it was beginning to feel like sooner or later one of the quakes would be catastrophic.

Although the county was largely spared in 1750, with the exception of some chimneys that were thrown down, it illustrates that parts of Rutland have at times come perilously close to being obliterated. For example, Market Overton's windmill was destroyed during a

terrifying thunderstorm in July 1745, with the miller and a servant of the village's minister being killed by lightning. The *Penny London Post* reported: 'What is more remarkable, a shilling and a sixpence in one of the men's pockets was melted all round the edges.'

On the morning of 3 September 1800, a tremendous storm broke over the county, and for three-and-a-half hours rain fell continuously in torrents, accompanied by thunder, lightning and hail. According to the *Gentleman's Magazine*, 'Parts of the Vale of Catmose resembled the river Thames.' Cattle, innumerable sheep and everything moveable was swept away in the deluge, and Oakham sat under a yard of water. Women and children working in the fields had, in places, to wade through water almost up to their shoulders as they attempted to get home; while at Empingham, 'the water rose above the windows of two cottages, on the right of the bridge; the inhabitants were obliged to seek a less exposed shelter.' (This probably means Church Bridge, over the Gwash, which in 1880 suffered from the effects of further flooding, the mail cart from Stamford being cut off.)

Equally horrendous was the fire on 29 May 1776, which almost obliterated Belton. The inferno started when a servant girl threw some hot ashes into a yard near the south end of the village, which – the conditions being tinder-dry – set fire to litter that was then fanned by strong winds across the street. As most of the buildings were thatched they were burned to the ground as the fire roared northwards. Despite a heroic attempt by Oakham's Rutland Militia (using an engine brought from Uppingham) to bring the blaze

Belton's arches may owe their discolouration to an ancient fire.

under control, the fire burned for twelve hours. Twenty-seven houses were destroyed, besides outhouses, barns, corn-stacks and hovels. However, no one was killed because, providentially, most of the villagers were attending Uppingham's market, although some people suffered burn injuries tackling the blaze. Around 170 people lost everything, and were reduced to living on the charity of surrounding towns and villages.

Interestingly, an even earlier fire is said to have partially destroyed the Norman-era St Peter's Church in Belton in the fourteenth century. Scorching can still be observed on some of the piers in the nave – it takes a while for the eyes to adjust to it, but the pinkish arches are evidently darkly discoloured compared to the lighter piers.

Manton, too, was nearly wiped off the map in the eighteenth century. The newspapers in 1728 reported that a dreadful conflagration on 20 July had consumed houses, barns and stables. It seems to have started when a man carrying something extremely hot – coals or a torch – was caught in a gust of wind, which blew embers onto a thatched roof.

The county's historic buildings have not escaped unscathed either. Numerous destructive fires have raged their way through our halls and stately homes. Barleythorpe Hall is just one example. Built around 1848, this was Lord Lonsdale's mansion until 1929, and then the home of Mr Kimball, Loughborough's MP. On 20 October 1933 it suffered a catastrophic fire, from which the Kimball children only just escaped. The fire brought the roof down and lit up the sky for 20 miles as dusk fell. The hall was subsequently rebuilt,

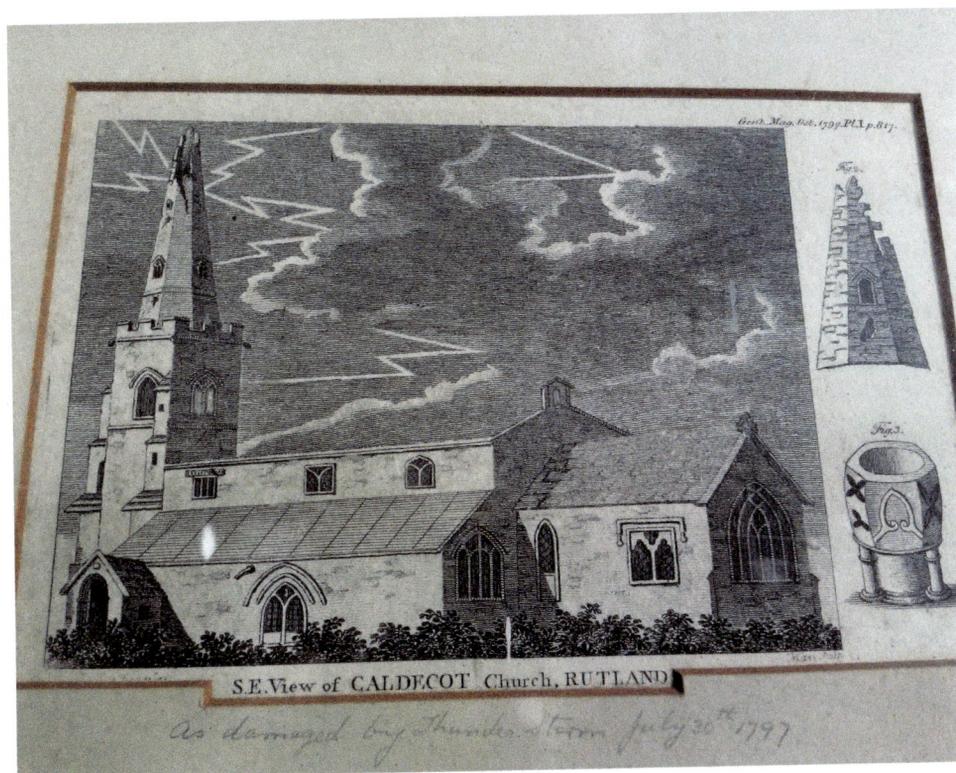

This image of Caldecott's church being destroyed by lightning in 1797 can be found in the building.

although nowhere near as grandly, and since then has fulfilled a variety of functions; at the time of writing, it is something of a building site, being turned into private dwellings, which will hopefully secure its future.

Finally, in 1958 there was great shock and sadness at the death of six-year-old Christopher Conant, the grandson of Sir Roger Conant, MP for Stamford and Rutland. The boy, who was heir to a baronetcy, died when strong gales blew a newly erected stackyard wall down upon him on 28 April. The accident happened at his father's farmstead, Middle Hambleton's Old Hall, a building dating to 1662, which used to be one of the favourite meeting points for the Hunt.

Seaton Viaduct

Prior to Rutland Water, the county's premier engineering feat was perhaps the Seaton Viaduct, built between 1876 and 1878 to carry the Leicester and Swannington Railway across the Welland Valley. Three-quarters of a mile long, this spectacular structure has eighty-two arches supporting it and is 70 feet tall. During its construction, a bronze brooch was found that had been lost by a Roman lady 1,700 years earlier. In 1939 it became necessary to post police guards along the viaduct, following information that IRA militants were plotting to blow it up.

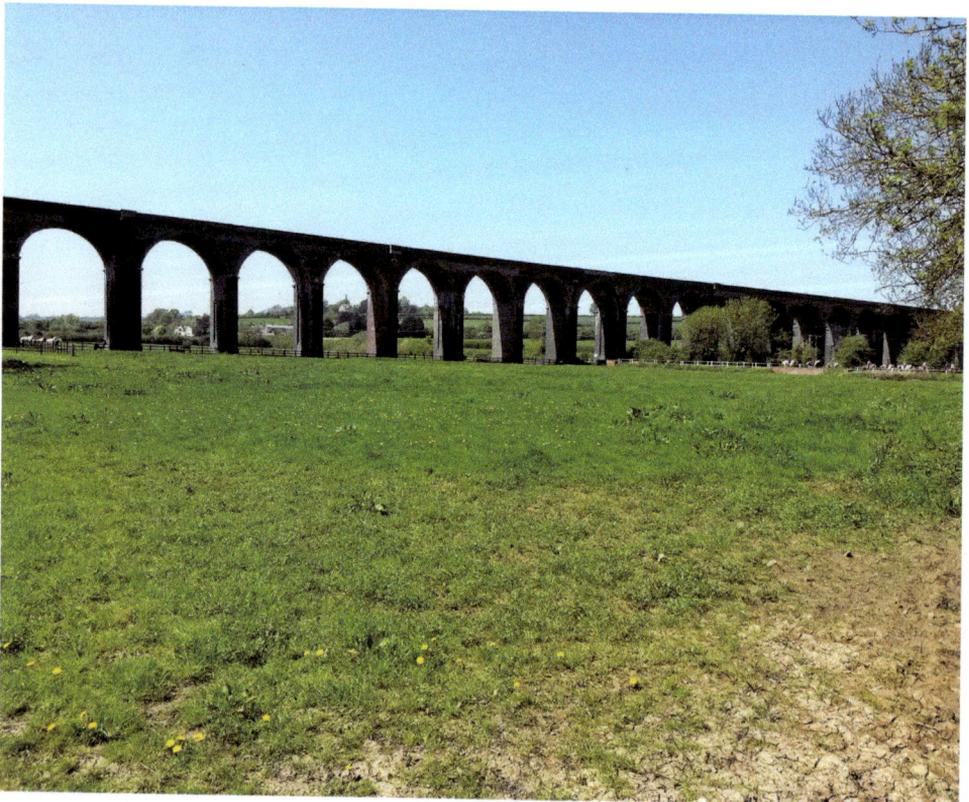

Seaton's viaduct.

Lost Customs

In the last decade of the nineteenth century a contributor to *Rutland Notes & Queries*, Edward Costall, observed a quaint custom in Market Overton that was then dying out: that of giving sweet buns to all the village children every 14 February. This custom had been practised since 'time immemorial' and seemed to be something to do with an era when weaving by handlooms was practised in many houses. The buns were called 'plum shuttles' as they were oval in shape, like a weaver's shuttle. Nearby, Barrow and Teigh had also formerly participated in this mysterious event.

Mr Costall ruefully observed, 'As the old families have died off, or left ... the number of donors has diminished, until at the present time I am the only one left who keeps up the custom, and when I am gone it will probably die out altogether.'

There is a record of a version of this custom being practised in Overton as late as 1920, when currant buns called 'skittles' were handed out to the children on Valentine's Day. After that, like the Market Overton Feast (on the Sunday after 29 June) and Ploughboy Monday festivities before it, the custom of handing out 'Valentine's buns' seems to have died out in Market Overton.

(On Ploughboy Monday, village farmworkers would dress in ragged clothes, disguise their faces and invite themselves into houses to recite rhymes – hoping for money in return.)

In old Ketton there were other diversions. According to the 17 November 1786 edition of the *Stamford Mercury* a raging bull was let loose in the village and baited for sport by the 'mad inhabitants' prior to its being slaughtered by a butcher. On this occasion the bull tossed a number of people and seriously injured one man in the head by goring him. According to the *Mercury* this cruelty was 'a very ancient custom'. (Bull Lane and Pied Bull Close derive their names from the Pied Bull Inn, not the blood sport. The inn was destroyed in 1935 after a chimney fire.)

One pastime not lost is the traditional – and to some inexplicable – pub game of 'nurdles', which centres around throwing a penny into a hole on a bench. The Jackson Stops Inn in Stretton is now the setting for the Nurdling World Championship, which is held there every May. The game uses pre-decimalisation coins and has been played there since time immemorial. The tournament became 'international' following the unexpected victory over locals by a Hungarian visitor in 2011. The bench, with its small circular hole, is set against a wall in the snug bar. A tray is fixed underneath to catch the coins that go in the hole, while a lead panel protects the wall from damage that would otherwise be inflicted by the greater volume of coins that miss!

A Royal Urban Legend

A story passed to the authors at Rutland Castle concerns Edward VIII. In the 1920s, when he was Prince of Wales, Edward is supposed to have been out hunting in fields near Whissendine. He and his brothers became separated from the hunting party and encountered a local farmer, who shook his fist at them and began ranting about the royal hunting party riding over his land. He ended by saying, 'And if you see that bloody Prince of Wales, tell him the same!' Edward is said to have diplomatically replied, 'I will make sure to do so sir, if I see him!'

2. War and Conflict

The Site of an Ancient Battlefield

In 1016 a large-scale battle was supposedly fought near Essendine between the forces of Edmund Ironside (aided by the parish's baron and the townsfolk of Stamford) and the Danish army of King Cnut. Numerous ancient chroniclers suggest the English king might have won the day were it not for the treachery of his ally Edric Streona, who deserted and took his supporters with him. Although Edmund escaped the battlefield there was great carnage, and thereafter Cnut controlled England. A great swathe of the English nobility are said to have either died on the battlefield or been executed in cold blood afterwards by the victors.

In truth many consider Essendine to have been accidentally misidentified as the battle's location, favouring Essex. However, a correspondent to the *Stamford Mercury* of 16 May 1862 was confident enough to suggest that the battle's location was in the meadows west of Park Farm, following the discovery of bronze spearheads, battle axes and coins there. In the centre of one field was an artificial circular high mound of considerable circumference, which was long believed to be the site where the Anglo-Saxon army assembled around their standard. George Burton's *Rambles Around Stamford* (1872) added the detail that Cnut traditionally built the original church at Essendine to commemorate his success, appointing Stigand his priest to pray for the souls of those killed in the fighting. Furthermore, 'many skeletons of men have been found in the locality'. These included a jumble of skeletons found by labourers digging ballast for the Great Northern Railway in 1851 near Banthorpe Lodge.

The Lyddington Market Raid

Lyddington is rather more famous for the Bede House than its aforementioned cross. The Bede House originated in medieval times as the wing of a palace built for the bishops of Lincoln – an episcopal residence that may have developed with the acquisition of Lyddington by Bishop Remigius in the late eleventh century. The Bede House represents only a portion of the former bishop's palace, but it is strikingly well preserved. The upper floor's Great Chamber, with its richly carved 500-year-old ceiling cornice, remains as impressive now as it did when the bishop's visitors were entertained there. Legend has it a priest's hole exists in the hidden recesses of the structure, reachable at one time via the wide fireplace.

The bishops of Lincoln not only represented the Church but acted as powerful manorial lords, controlling the local population and – occasionally – ruthlessly policing them. During the tenure of Bishop Richard de Gravesend, at a time when the palace may have been little more than a hunting lodge, one 'Robert' was caught stealing a ham from the bishop's pantry: he was tried in the bishop's court and hanged in 1263.

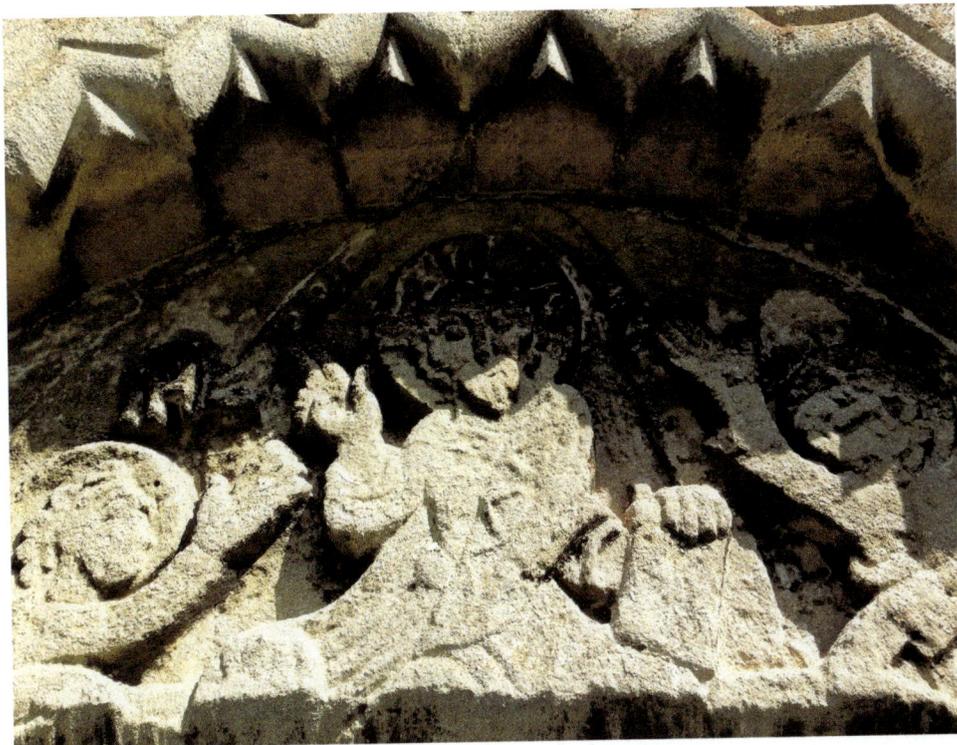

Essendine's church doorway is Norman – although this tympanum adorning it is held to be from the earlier Saxon era.

The bishop did, at least, support the village, intervening on occasion to protect its market rights. Fairs and markets were held here, and it is possible Lyddington began to see itself as a developing town; however, the promotion of the village and the affluence these events brought generated intense and violent rivalries with surrounding towns and villages. In 1366 an armed crowd from Uppingham raided Lyddington's fair, killing a man called William Wade in the melee and brutally assaulting the sheriff. The merchants were driven out of the parish with threats of even worse violence.

One wonders whether the late fifteenth-century polygonal watchtower, which marked the palace's precinct and offered elevated views of the property, was designed for defence during times of instability like this. Nonetheless, Lyddington's pretensions to town status never materialised and the palace underwent extensive changes. Ultimately, the Crown seized what was left in 1547. Around 1602 Thomas Cecil, son of the powerful Elizabethan statesman Lord Burghley, converted the palace into a 'bede-house' (or poorhouse) after it passed into his family. It continued in this use up until the 1930s, when it was still a home for pensioners, after which it remained empty for some time before being taken into guardianship in 1954 and painstakingly restored.

Another medieval skirmish occurred on the highway near Exton in June 1336. This happened to be the location where the abbot of Vale Royal Abbey's entourage was ambushed by a small army of disgruntled Cheshire peasants led by a personal enemy,

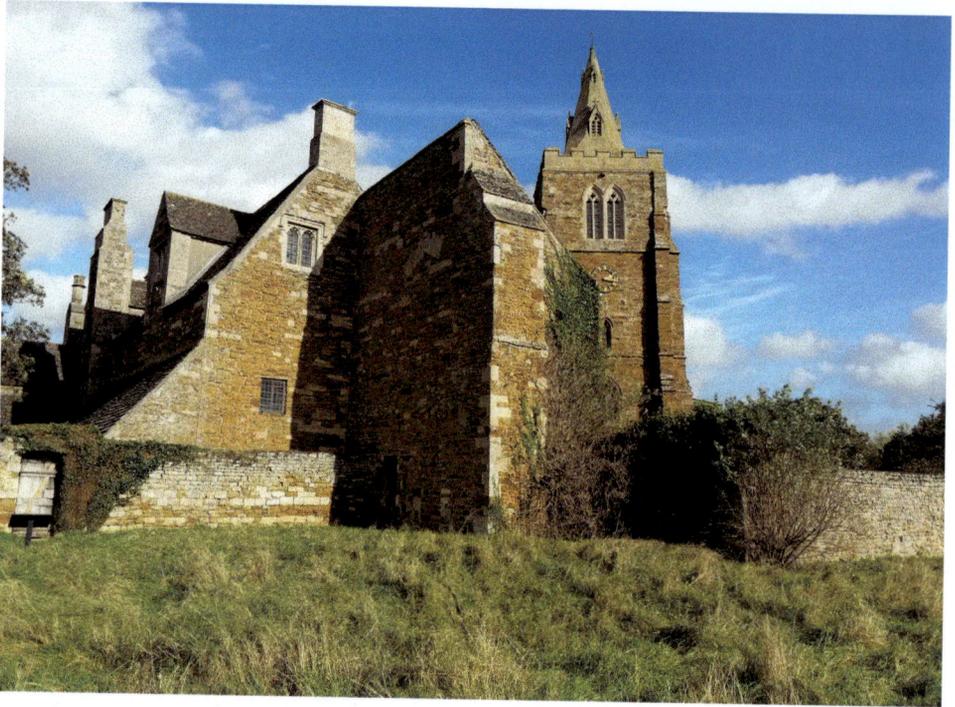

Lyddington's Bede House and church.

Sir William Venables of Bradwall. Abbot Peter had been visiting the king at King's Cliffe, Northamptonshire.

The abbot's horse attendant, William Fynche, was killed when an arrow was fired into him, and there followed a pitched battle that only ended when more of the abbot's attendants under Walter Walsh and John Coton rode to his rescue, beating back their opponents with enormous bloodshed. At this point it seems 'the bestial men of Rutland' got involved, intervening to capture Abbot Peter and transport him to Stamford. He was later released by the king, and those who apprehended him were imprisoned. Ten Cheshiremen were also indicted for Fynche's murder, but were liberated after forfeiting their goods to the abbot. Others involved in the ambush were jailed in Weaverham Prison, Cheshire.

As a result of the vendetta against him, Abbot Peter was assassinated in Cheshire around two years later.

The grounds of Holy Trinity Church, Teigh, were the setting for yet more medieval violence. In the fourteenth century the younger members of the Folville family of Leicestershire were a disorderly and violent group of malefactors. These included Richard de Folville, the rector of Teigh, a man linked to robberies, homicides, vigilantism and marauding. By c. 1341 the authorities had had enough of this outlawed clan and they besieged Teigh's church, where Richard and his followers had barricaded themselves in. Richard and his supporters fired arrow after arrow at their besiegers from the church tower, killing one man and wounding others. In the end, Sir Robert Coalville and an

undersheriff battled their way inside the church and seized the lawless rector. Richard was then dragged outside and summarily decapitated, possibly in Main Street. Sir Robert Coalville and his men were whipped at a number of local churches in punishment for this as his original instructions had been to take Richard alive to London and imprison him in the Tower.

DID YOU KNOW?
During the Second Baron's War (1264–67) against Henry III, Oakham was ring-fenced for protection. Despite this, the town was taken by local revolutionaries supporting the rebel Earl of Leicester, and the castle hall was damaged by fire.

Losecoat Field

Without doubt the county's worst carnage occurred on 12 March 1470 when the insurrectionist army of Sir Robert Welles, principally made up of Lincolnshire men, was routed by Edward IV's Yorkist forces east of the now-defunct medieval village of Horn in the vicinity of a coppice known as Bloody Oaks by the Great North Road. Prior to the battle, Edward had Sir Robert's father, Lord Welles, and another hostage executed in cold blood near the Queen's Cross, Stamford, which triggered the fighting. The Yorkists won the day, with 10,000 slain. On the eastern side of the Great North Road a piece of land has earned the name Losecoat Field (north-west of Tickencote Warren). According to local lore some fleeing rebels cast off their coats hereabouts since they were impeding them in their escape. Sir Robert was taken prisoner and very swiftly afterwards executed.

The final stand by the rebels is held to have been at Church Bridge, Empingham. In lowering the ground at the entrance to Empingham Rectory in 1835 several skeletons were unearthed, believed to be those of people killed fleeing the battlefield.

It was also during this conflict that Pickworth's church is likely to have been destroyed, subsequently earning the remains of the steeple the nickname 'Mock-beggar'. Now even the steeple is gone – it was taken down in 1728 and 1731 – and all that remains is one of the arches of the tower. This stands on Manor Farm's private land, but can be clearly seen from the road that joins The Drift, an ancient drover's route to London.

A classic legend, naturally, developed after the battle. It became said that the then owners of Tickencote's manor house buried the family's silver plate in the grounds for fear one side or the other would steal it during the war. The owner died in the battle, as did the family retainer – the only other person who knew the secret of its whereabouts. By the early 1600s the Wingfield family held the manor of Tickencote and later generations living at the hall attempted to discover the 'Tickencote Treasure', as it became known. As late as 1912 the writer Charles Harper recorded 'an unavailing search in recent years' had been made for the valuables. The last of the Wingfields died in 1931, and by the 1950s Tickencote Hall had been pulled down – with the treasure remaining unfound to this day.

The modern sculpture at Pickworth.

Oddly, at the time of writing, no monument at Losecoat Field signifies to the passing traveller that this was once the scene of such catastrophic slaughter, although there is a stirring sculpture (2015) of a warrior shedding his coat outside the nineteenth-century All Saints' Church, Pickworth.

Susannah Noel's Effigy

One of the most impressive monuments in Rutland is that of Susannah Noel in St John the Baptist's Church, North Luffenham. It is exquisitely lifelike, although somewhat damaged; however, this is not due to neglect. Susannah's mutilated nose and broken fingers are physical evidence of the Stuart-era Civil War between king and Parliament having come to Rutland; they are also a snapshot of a moment in time that occurred over 350 years ago now.

North Luffenham was besieged by Parliamentarians under Lord Grey on 20 February 1642/3, and the defence of Luffenham Hall by Henry Noel Esq, Susannah's husband, is semi-legendary here. Lord Grey had earlier been frustrated in an attempt to take Henry's father and elder brother at Brooke as they had flown to Nottinghamshire, and so Henry himself became Grey's next target. The nearby hamlet of Sculthorpe (approximately where Settings Farm is) was obliterated and Luffenham Hall was surrounded by 1,300 troopers.

Susannah Noel's vandalised effigy.

By the time his adversaries arrived Henry was backed by some 200 county folk. A severe engagement took place in which one of Lord Grey's men (Catesby, a lieutenant) was fatally wounded. Henry's much inferior force, besieged within the hall, next withstood cannon fire that was blasted in their direction. Legend has it that the defenders attempted to fire their own home-made cannon in retaliation. This had been improvised from an iron-bound butter churn filled with lumps of metal and gunpowder; when lit, it exploded, badly injuring the firing team.

It was only when Henry learned that the Parliamentary troops had set six of his neighbours' cottages on fire – and were threatening worse – that he surrendered. The hall was thoroughly ransacked and two maids assaulted before Henry and his principal ally, Mr Skipwith, were transported as prisoners to London.

Mercurius Rusticus, a contemporary newsletter, recorded how the troopers vandalised the effigy of Henry's wife, Susannah Noel, who had died in 1640, 'deeply wounding the living husband, by spoiling that memorial which he had consecrated to the dear memory of his dead wife'. This is the damage that can still be seen today. Henry Noel himself died that July while still a prisoner.

Because (as per Susannah's memorial) their only child died aged just three days old, the hall descended to Henry's nephew. Luffenham Hall was pulled down in 1806.

1631	Edward Marten		William Bishop
1637	Jeremiah Taylor	On resignation of above – In 1642 Jeremiah Taylor was called upon to attend King Charles I as Chaplain. In the same year his living at Uppingham was sequestered by Parliament. Afterwards Bishop of Down & Connor.	
1660	John Allington M.A.		
1682	Thomas Stockman	on resignation of above	
1684	George Barry M.A.	on death of above	
1689	William Standish	on resignation of above	
1743	John Jones L.L.D.	on resignation of above	
1752	James Harwood. M.A.	on death of above	

This plaque in Uppingham's church shows the position of rector was abolished by the Parliamentarians for eighteen years.

I understand from conversations with the churchwarden here a few years ago that it stood approximately where the school now is, and that the current North Luffenham Hall was the former Digby manor house.

In June 1853 some twenty-two skeletons were unearthed on a ridge of land near the Whitwell road, a little out of Exton. A contributor to the *Gentleman's Magazine* at the time suggested the remains were contemporary with the North Luffenham siege. Two coins found with the skeletons were dated to the mid-seventeenth century and therefore: 'I cannot but conclude that these skeletons were so many slain in the Great Rebellion about the period when Burley House (on the Hill) was burnt by the rebels, and also Great Luffenham Manor-house was plundered.' The suggestion is that the skirmishing in Rutland claimed more lives than originally thought. This bears out a report in *Mercurius Aulicus* (5 March 1642/3) suggesting twenty-eight people died in the besiegement of North Luffenham.

Oakham escaped the Civil War relatively unscathed, largely through the endeavours of Sir Thomas Fairfax, a Parliamentarian who took Burley but opted to protect Oakham church's carvings. Parliamentary troopers did, however, vandalize the castle; and in 1647 a young man named John Halford died in what seems to have been a large-scale political brawl in the town.

The Uppingham 'Bear' Massacre

Uppingham, Rutland's second town, does not appear to have been the scene of any major battle during the Civil War between Charles I and Parliament; yet a pamphlet of the time, *Mercurius Rusticus*, tells us that the town was nonetheless the setting for a strange and sad episode during that conflict.

Under the date '27 July 1643' the passages from Parliament give an account of how the queen, in arriving from Holland, was accompanied by a group of 'savage ruffians' who brought with them a number of 'savage bears' from the Netherlands for sport. These animals were, apparently, left in Newark, Nottinghamshire, and ended up being taken to a number of towns across the Midlands for exhibition.

Oliver Cromwell, then a colonel, bringing his forces by chance through Uppingham one Sunday, found a number of these wild animals had been left in the town, where they reportedly either played or else were being baited by the townsfolk.

Annoyed at such 'fun' taking place on the Lord's day, Cromwell ordered the animals to be tethered to a tree and summarily shot – the main purpose being to put an end to the irreligious merriment the creatures were causing in Uppingham, rather than an act borne out of pointless cruelty. One assumes the bears were not quite as savage as suggested, but tame and small.

William White's *History, Directory & Gazetteer of Leicestershire and Rutland* observed in 1846: 'A building in Orange lane, Bear House, was standing not very long ago, and probably derived its name from this occurrence.'

DID YOU KNOW?
The diarist Luttrell recorded on 28 March 1693 that a company of foot soldiers had clashed violently with some butchers in Oakham; one of the latter was killed, and others wounded on both sides. He wrote, 'The disorder appearing to be occasioned by the soldiers, severall of them thereon are committed.'

Belton in the Civil War

In Belton's church there is more evidence of the Civil War having come to Rutland. A deep V-shaped incision on one of the pillars is commonly believed to have been caused by Cromwell's men sharpening their swords there. Another theory suggests the groove was caused by medieval archers sharpening their longbow arrows, after Mass on Sunday mornings, however. The Parliamentarian troopers caused much damage in St Peter's, destroying most of the furniture and stabling horses in the nave. The thirteenth-century font was tossed into a nearby field, where animals used it as a drinking trough for a long time.

Outside the church, Belton's twentieth-century war obelisk stands on an ancient base called the King's Stone. This is from the belief that King Charles sat and rested on it during

King's Stone and war obelisk.

his flight from the Battle of Naseby, Northamptonshire, in 1645. It is unlikely Charles passed through Belton, though, so perhaps the stone was imported from elsewhere – and the story came with it.

The World Wars
Jumping forward to the twentieth century, war memorials to those lost in the trenches of the First World War can be sought out in most villages, evidencing the suffering the conflict brought to Rutland. A peace memorial shrine in Uppingham School's chapel brings it home: here, wooden angels look down on the names of over 400 former pupils who fell in the conflict. The memorial was established in 1921 by Ernest Newton, an old boy of Uppingham.

The death of twenty-nine-year-old Julian Richards of South Luffenham is typically poignant. He was one of the dozen vicars' sons from Rutland to be killed in the First World War, dying at the Battle of Loos in 1915. He was buried at a farm in Vermelles, France, but his grave was later lost. His grieving father erected a plaque in St Mary's Church, reflecting the sorrow felt by all at Julian's loss, which can still be seen.

Uppingham's chapel is guarded by the statue of Edward Thring, the school's legendary headmaster who died in 1887.

Teigh in particular is significant for its wartime fortunes. It is the only village in Rutland where all those who went to fight in the First World War returned home – the so-called 'Lucky Thirteen'.

Rutland was regularly visited by German Zeppelins during the First World War. The county escaped the large-scale destruction suffered by other areas, but the fear these deliverers of death created was very real, and the damage sometimes significant. On 5 March 1916, for example, fifteen bombs were loosed by an airship between Sewstern and Thistleton. Newspapers of the time were cagey about providing specifics of locations targeted, but the *Grantham Journal* reported four bombs fell in a ploughed field 'a hundred yards or so from the edge of one village, and near a spot which achieved fame over 100 years ago from a certain sporting event'. Following the newspaper's clues, this must have been approximately between Thistleton and Thistleton Gap, site of a legendary boxing bout. The *Journal* reported that the craters created by the bombs were so huge a horse and cart could turn around inside them, and throughout the week a great number of curious people visited the bombed location. The fact the Zeppelin bombed Rutland at 11.30 p.m. doubtless only added to the alarm. But quite why the Zeppelin bombed

this open countryside is unclear; a local theory had it that its searchlights mistook large stacks of turnips for ground-force tents. In Oakham's museum there can be seen a large fragment of shrapnel from a Zeppelin bombing raid in 1916; one wonders if it was picked out of the Thistleton crater.

Of the Second World War, the arrest and imprisonment of Teigh's rector in July 1940 as a suspected Nazi-supporting fifth columnist is perhaps more a reflection of local rivalries and village tittle-tattle than an indictment on his true guilt. A number of people appear to have borne personal grudges against Mr H. S. Tibbs, who was accused of spreading defeatist propaganda among his parishioners and even sheltering two Gestapo agents inside the rectory. Tibbs was imprisoned without trial for a short period – most sources suggest at Liverpool, although the National Archives mentions Ascot. He returned to Teigh a broken man, suffering from pneumonia he caught in prison. Tibbs died in 1943, reportedly declaring his life had been 'completely destroyed'.

Building of RAF Cottesmore commenced seventeen years after the end of the First World War in reaction to Germany's rearmament. The airfield at North Luffenham opened in January 1941, following the advent of the second war with Germany. RAF Woolfox opened that same year as a satellite to RAF North Luffenham. The very real heroism and drama occasioned here during the war years is now difficult to imagine, the conflict having ended over seventy years ago. But at one time the skies over Rutland

This list of vicars in Teigh's church shows 'Benefice Vacant' after Tibbs's death.

would have been full of bombers and other aircraft, not all of them friendly: RAF Cottesmore, for instance, was attacked and bombed by German pilots in 1940 and 1941. Add to that the planes that collided in mid-air or crashed in fields, the Rutland villages that were strafed by enemy fighters, the dogfights that occurred in the skies over the county, the fatal accidents that occurred regularly on the airfields and local roads, and the sustained threat, and we begin to appreciate just what it might have been like during the war years for the average inhabitant of Rutland. In one of the worst incidents, on 8 July 1944 two Dakotas out of Spanhoe Airfield, Northamptonshire, collided over Tinwell and plummeted into Long Meadow, near Pile Bridge. The disaster killed thirty-four people, although Corporal Thomas Chambers, of the US 9th Air Force, managed to jump from the doorway of one of the stricken craft, landing in the mud of the River Welland's banks and surviving.

Places like this are dotted across Rutland. At Edith Weston, for example, a plaque on the church wall explains that on 4 March 1945 a Lancaster bomber crashed 100 yards to the east. It burst into flames and eight people died.

North Luffenham for a while became a Cold War Thor missile base, nicknamed 'Little America'. At the time of writing (2018) it still has concrete launch pads and blast walls; although today there is more talk of the old airbase being developed into a 'garden village'. (Google Earth shows mysterious craters scarring the runway, possibly the result of some form of training exercise.) RAF Woolfox, too, had Bloodhound surface-to-air missiles installed; but the station became inactive in 1966, and today it presents a vast, tarmacked grassy plateau used largely for agriculture, dotted with eerily deserted wartime buildings. RAF Cottesmore survived as an RAF base the longest, in 1957 becoming home to aircraft of the V-bomber force, carriers of Britain's nuclear deterrent. Many today will remember the disastrous crash of a Vulcan bomber from Cottesmore on 30 January 1968, which saw the aircraft nosediving into land near Cow Close Farm, between Burley and Exton. Newspaper images of the time show just how close the farm came to being completely obliterated, for the bomber miraculously just missed the buildings, although tragically four crewmembers died. The pilot and co-pilot managed to eject just in time.

Nowadays, both RAF Cottesmore and RAF North Luffenham function as army barracks, the RAF squadrons having either been disbanded or moved elsewhere.

One wartime relic worth seeking out is situated beside a barely used track called Teigh Lane, Whissendine, near the remains of a medieval moated site. Here stands a long-abandoned Second World War pillbox. These were a type of concrete guard post, complete with small openings for challenging enemies and opening fire in the event the German invasion succeeded. Another can be clearly seen on the southern side of the A47, past Morcott on the way to Uppingham. There are a few locations like this scattered about Rutland. The north-eastern corner of Cutts Close, Oakham, for instance, was the site of a gun emplacement in the event that the Germans took RAF Cottesmore and advanced on the town. Today places like these are the visible echoes of an era (still within living memory for some) when this nation was engaged in an all-consuming war to combat a threatened invasion.

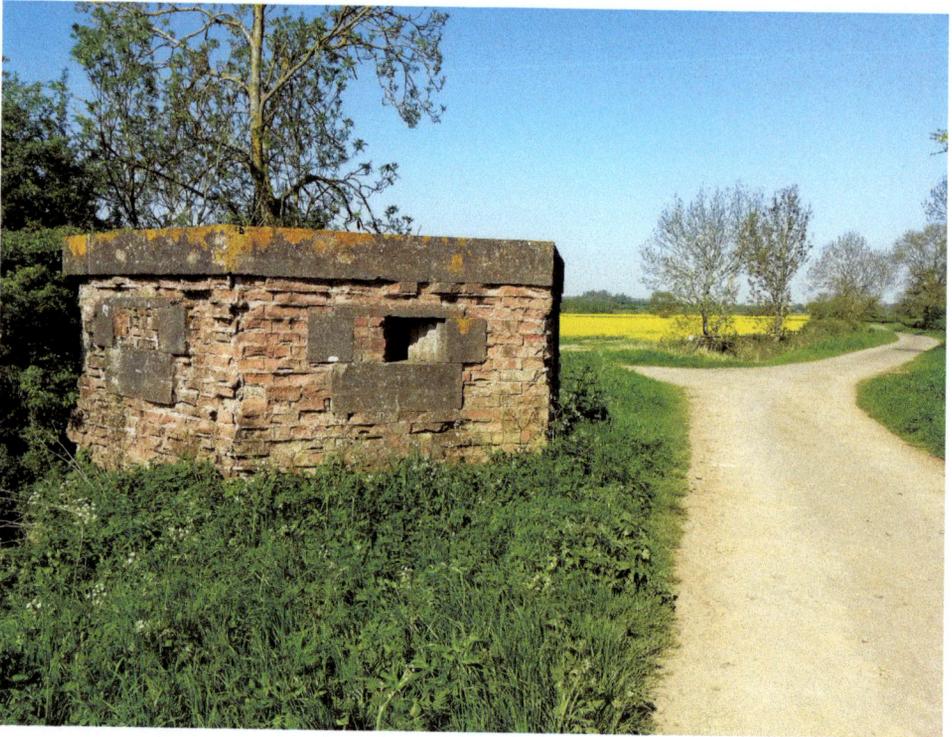

Pillbox near Whissendine.

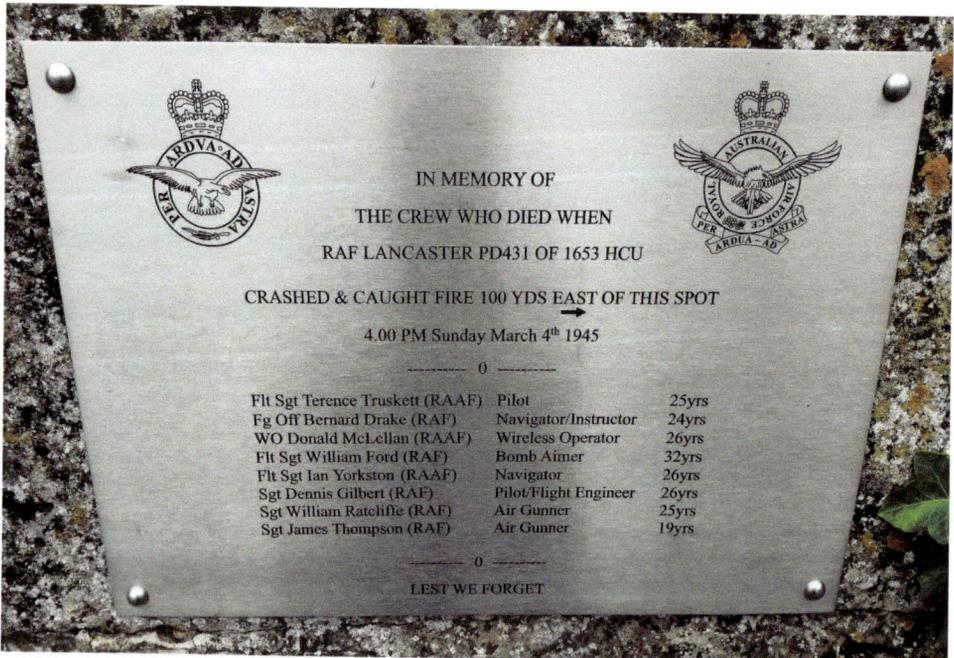

IN MEMORY OF

THE CREW WHO DIED WHEN

RAF LANCASTER PD431 OF 1653 HCU

CRASHED & CAUGHT FIRE 100 YDS EAST OF THIS SPOT →

4.00 PM Sunday March 4th 1945

———— 0 ————

Flt Sgt Terence Truskett (RAAF)	Pilot	25yrs
Fg Off Bernard Drake (RAF)	Navigator/Instructor	24yrs
WO Donald McLellan (RAAF)	Wireless Operator	26yrs
Flt Sgt William Ford (RAF)	Bomb Aimer	32yrs
Flt Sgt Ian Yorkston (RAAF)	Navigator	26yrs
Sgt Dennis Gilbert (RAF)	Pilot/Flight Engineer	26yrs
Sgt William Ratcliffe (RAF)	Air Gunner	25yrs
Sgt James Thompson (RAF)	Air Gunner	19yrs

———— 0 ————

LEST WE FORGET

Memorial plaque to a wartime disaster at Edith Weston.

3. Places of Worship

St Tibba

Ryhall, around 2 miles north of Stamford, is closely associated with St Tibba.

Tibba is believed to have been a virgin anchoress (a female religious hermit) from Godmanchester, Cambridgeshire. Quite how she came to Ryhall in the first place is unclear, although she may have owned the parish. She was a niece of the Anglo-Saxon King Penda (d. 655) and some say she was a wild girl in her youth with a passion for hunting, before adopting the life of an anchoress. We know she was interred at Ryhall because it is written in the Anglo Saxon Chronicle for the year 963 how Elfsi, an Abbot of Peterborough, 'took up the bones of one Tibba, that was buried at Rihala (Ryhall), and offered them for a great present to St Peter of his abbey'.

Tibba is the patron saint of falconers. It is said that those who had lost their falcons in days past were encouraged to take offerings in the form of a wax hawk (or any other offering, for nothing was refused) to her shrine at Peterborough, whereupon they would shortly reclaim their bird via divine intervention. However, falconers were often of a comparatively wealthy disposition and not overly given to pilgrimages; therefore, the custom is likely to have been invented as a lure to bring these types of people to Peterborough with their donations. The hunter's cry of 'Tantivy' may be a corruption of a call for assistance from 'Sancta Tibba'.

Nineteenth-century writers observed that there were still a number of traditions regarding St Tibba in Ryhall. Some there called her a queen (which would not be entirely erroneous if she was Penda's niece). Others claimed to know she bathed in a spring called Tibba's-hill well, or Tibbal's-hill spring, near the road leading from Ryhall to Little Casterton. The famed eighteenth-century antiquarian William Stukeley observed, 'On the brow of the hill, near the spring, is Hale-green, as it is still called, taking its name from the anniversary meetings held here in former times, in memory of Saint Tibba, whose day is Dec. 16.' (This day was commonly thought to have been the date of her death, although some celebrated St Tibba's Day on the 14th.) A small grassy hillock in a field to the east of Tolethorpe Hall is popularly supposed to be the well's site.

These days, it is said that her small hermitage was situated on a spot now covered by St John the Evangelist's Church, Ryhall, at the west end of the north aisle. Maybe she died there. Nothing here denotes this, however, although according to the *Grantham Journal* in 1903 the church had a niche 'which contained a figure of the Saint within the memory of persons still living'. Equally intriguing is the suggestion that a twelfth-century interior door-jamb carving at Essendine's church reflects the cult of St Tibba, possibly representing two hunters wielding sticks. If so, this might mean the depiction postdates the lifting of Tibba's relics from Ryhall to Peterborough by only a couple of hundred years or so, when her veneration may have been at its height locally.

Site of St Tibba's Well.

Brooke Priory

Brooke Road, between Braunston and Brooke itself, takes the visitor past a series of very obvious grassed humps by the road, interspersed with scattered tree lines. This is all that remains of Brooke Priory, founded for the Augustinians by Hugh de Ferrars around the time of Richard I, which – although historically unremarkable – is yet notable for having been the only monastic house in Rutland.

Its occupancy appears to have been in single figures, and its function was probably mainly administrative. A remote cell linked to Kenilworth Abbey, it struggled financially and many saw their secondment to it as little more than punishment. It survived until 1535, when it surrendered to Henry VIII. There is a local tale that a tunnel ran from the priory all the way to Launde Abbey in Leicestershire. It is held that at some point a fiddler ventured down into it at the Brooke end, playing his violin so that those above ground could follow his progress. Halfway through the fiddling stopped and the explorer never reappeared; his friends could find no trace of him when they ventured

in themselves to look. (This is not the only legend of tunnels in Rutland: every other building of any historic significance seems to have some attached story of a subterranean passage radiating out from it.)

From 1549 there stood a mansion called Brooke House at the site, built by the Noel family using the priory's stonework, although this has all but disappeared too, save for the gateway and octagonal porter's lodge, which is now a dovecote. This can also be seen from Brooke Road.

The medieval village of Brooke was sited just to the south-west of the priory, and another tale has it that some of the earthwork banks hereabouts were fortified by Parliamentary forces active during the Civil War. This is entirely possible, as even today the grassy remains are singularly impressive in both size and scope. It was the Parliamentarians who pulled down Brooke House, and Cromwell himself is said to have visited the place, stabling his horse in the courtyard. In *The Villages of Rutland* (Vol. I, Part I), an interesting local story is told. When Cromwell's men were pulling down Brooke House, a man wearing a nightshirt escaped through the priory grounds and hid in an oak tree there. When he was able, he ran to the nearby village of Martinsthorpe (now defunct) and warned its inhabitants of Cromwell's arrival; however, not long afterwards he died of exposure. His ghost is now said to wander the area between Brooke and Martinsthorpe.

A large farmhouse – Brooke Priory – was then built on the site of the Noel's ruined mansion, incorporating the same masonry and utilising the same cellar that had been spared the destruction. It is in this form, as well as the earthworks, that Rutland's unique

The site of Brooke Priory.

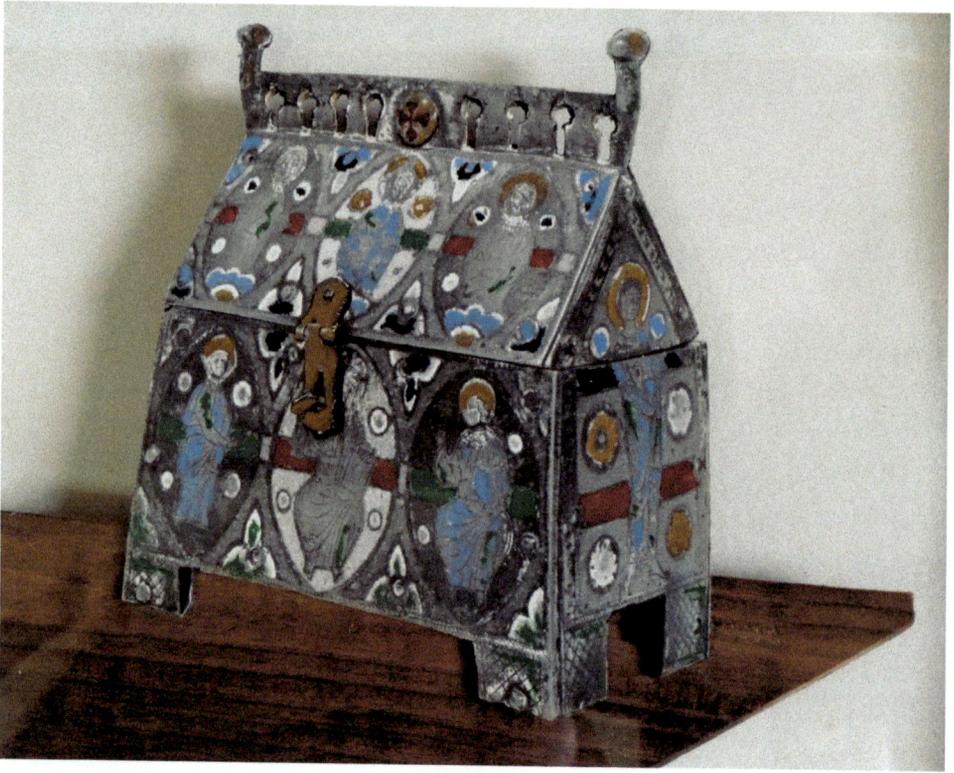

The Brooke Reliquary, depicted in Brooke's church.

priory survives. Additionally, a fine enamelled reliquary, dated *c.* 1210, was discovered around 1805 hidden in the cellar of the priory house. Made in Limoges, France, it likely contained the relics of an unknown saint. It was probably hidden around 1540, during the Dissolution. At the time of writing, it is held at the Rutland County Museum.

A tiny Benedictine establishment also sat at Edith Weston, although Pevsner's *The Buildings of England: Leicestershire and Rutland* (1960) thought it so insignificant that it 'can hardly be called a priory'. Although the fishponds are still marked on maps, any other remains now lie under Rutland Water.

The Sanctuary of Geoffrey Cokerel

The churchyard of All Saints' Church, Oakham, was the site of a remarkable preservation in 1349. According to the calendar of the patent rolls, Geoffrey Cokerel had lately been detained in Oakham Castle's gaol on suspicion of stealing four cows. He accused a number of other men of his crimes, although the justices under William de Thorp acquitted these people of the larcenies and convicted Cokerel alone. Geoffrey was actually strung up and hanged on this basis – although not very effectively as it turned out, since he was subsequently revived in the cemetery of All Saints' after lying there 'dead' for some time. He thereafter sought sanctuary within the church itself until a royal proclamation dated 2 April 1349 pardoned him, allowing that his deliverance was miraculous.

The Ayston Double Effigy

A curious stone double effigy can be found in St Mary the Virgin's Church, Ayston, which is badly weathered due to its being kept in the churchyard until the 1960s. This approximately fourteenth-century monumental slab depicts a knight with his shield and sword lying over him, and his lady by his side; his hands are in prayer, hers are not. Alternatively, the 'sword' has also been interpreted as a holy cross, with the two figures suggested to be priests.

The eroded condition of the effigies, together with the fact that whom they represent is unknown, has prompted several theories down the years. Joshua and Raphael Brandon's *Parish Churches* (1848) noted the belief that the figures were those of twin brothers – 'born united together' – who lived locally and had the effigies placed over their grave when they died. Another version suggests the figures represent twin sisters, born with one arm each, and that their hands are pushed together in prayer. Legend has it the one-armed sisters made so much money by their industrious spinning that they earned enough at last to buy a field. This was left as a legacy to benefit the poor of Uppingham.

Ayston's curious effigy.

This last theory is clearly erroneous; anyone can see that the effigies represent two distinct people, one with two hands in prayer. The secret here is who might the 'twins' have been; whose memory in Ayston lingered so long that the effigy was ascribed to them?

Rutland's Martyr

Little is known of the life of John Lyon, the man who has come to be known as the 'Rutland Martyr', beyond the fact that he is believed to have hailed from North Luffenham and in 1574 been married in that village to one Elizabeth Austin. It also appears he was a man of some standing, being a yeoman of the county of Rutland and the owner of 300 acres of freehold land.

At some point he renounced his Anglicanism in favour of the Catholic religion, and such were the times that this led to his appearance in 1599 before the magistrates at the Castle Hall in Oakham, where he was sentenced to death for refusing to renounce his Catholicism.

On 16 July 1599 Lyon was dragged through the streets of Oakham on a hurdle to the place of execution at Swooning Bridge. First he was hanged by the neck from a gallows, but ritualistically cut down just before he expired; then he was disembowelled and his

These clappers date to 1597, 1621 and 1723, and struck Edith Weston's church bells until 1951. Until 1928, the church also had a one-handed clock.

heart cut out. Lyon's last words are said to have been 'Lord, have mercy on them.' Many people in the mob were struck by his devotion and there was reportedly a clamour among them to dip their handkerchiefs into his blood. Even the minister who attended the execution was so moved that (according to tradition) he renounced his Anglicanism in a likewise manner, took himself off to Rome and subsequently returned a Roman Catholic, before being similarly martyred on the Tyburn gallows in London some time later.

To redress the injustice, in March 1919 a service was held at SS Joseph and Edith's Catholic Church on Mill Street, Oakham, in which a memorial tablet within the church was blessed by the Right Revd Bishop of Nottingham before a large crowd, many of whom had come a great distance. The tablet, in part, read: 'To the glorious memory of the Venerable John Lyon, the Oakham Martyr (for the Catholic Faith) ... Declared Venerable by His Holiness Pope Leo XIII.' (The church is, as of 2018, a hair and beauty salon.)

Our Lady's Well, Oakham

In 1756 a survey of the great highways and significant crossroads of Britain observed this of Oakham: 'The people of these parts formerly used to go in pilgrimage to a spring in this parish, still call'd Our Lady's Well, where offerings were made to the Virgin Mary, and St Michael the archangel.'

A later (1813) topographical work, Brayley, Britton and Brewer's *The Beauties of England and Wales*, provides a fuller description of this ancient custom, which seems to have been long discontinued even by the late 1600s:

Connected to [Oakham's] church, and the charitable concerns of this parish, was an ancient custom before the Reformation, for the pious and devout to go on a pilgrimage to Our Lady's Well, which is a fine spring, still in existence, and preserving the same name, about a quarter of a mile from the town. The foundations of houses were existing about a century ago; but of what kind, or for what specific purpose erected, there is no record. It is detailed, indeed, in a record in the First Fruits Office, that many of the profits and advantages of the vicarage of Oakham arose from the *obventions*, and pilgrimages which took place to this well, in honour of the Virgin Mary, and St Michael the Archangel. This holy juggling, however, has long been at an end, and with it have ceased the pilgrimages, offerings, etc.

However, as late as Victorian times, people would travel to the well and throw an offering of a pin into it, before washing their eyes with the water in the hope it would cure eye infections.

Of course, the area 'a quarter of a mile from the town' has now been swallowed up and incorporated into Oakham's town boundary. The boggy remnants of the spring and the trench that feeds it can be found in unremarkable scrubland between two rows of modern houses near the B668 and A606 roundabout. Sadly, the current journey to discover it is barely worth the effort as it is a far cry from the days when the spring was held in such veneration. Burley Road was in those days called Pilgrimage Way, such was the devotion.

This street at the site is named after the well.

Another venerated well, Chriswell, was on the opposite side of Burley Road. One story, long remembered in Oakham, concerns a Belgian refugee living in Rutland as a farmer during the First World War, who took his prize bull to Chriswell to drink. The animal was dying, but after partaking it miraculously recovered.

There is more to see on the lane to St Mary's Church, Greetham, where Jacob's Well is decorated by a Victorian stone surround, bearing the epitaph: 'All ye who hither come to drink; rest not your thoughts below; Remember Jacob's well and think; whence "living waters" flow'

This well is thought to have been developed specifically to cater for the needs of the children at the school opposite. A similar inscription adorns the attractive stone surround of the so-called 'Wishing Well' at Ashwell; although the reasons for this well, situated in boggy land on the village's edge, are even less clear. The spring has been described to me as a 'holy well', although there seem to be no traditions as to why, beyond: 'It's the reason why this village is called "Ashwell"!' The village name appears to derive from 'ash stream', implying the spring is ancient, but all that is definitely known is the date of the nineteenth-century arch-shaped alcove that surmounts it.

'Strewing the Hay' and other Charities

An interesting snippet in the *Grantham Journal* (8 July 1939) informs us that the 'old custom' of scattering rushes cut from the church meadow around the church interior had been performed at Barrowden on Feast Sunday.

Elsewhere, in Langham, this curious custom has been kept up in modern times. On the first Sunday after the feast of St Peter (29 June) newly mown hay is strewn around the interior of St Peter and St Paul's Church, having first been gathered from a small piece of land that was long ago bequeathed to the parish for the purposes of supplying the grass. The ritual probably stems back to the days when church floors were muddy: late June/early July was when the hay crop became available and therefore this would have been a natural time to scatter hay around the church's interior.

Notes & Queries observed in 1895 of the Langham hay-strewing: 'We are in ignorance as to the origin of the custom.' However, over the last half-century or so a popular story has developed that runs something like this. It tells of a well-to-do lady who set out one day on foot from Melton Mowbray, heading in the direction of Oakham where her father lived. The woman's father had lately been ill and so the lady braved the atrocious weather in order to go and care for him. After a while she became thoroughly lost in heavy snow, the landscape having become a blanket of white with no landmarks, and she was forced to seek shelter under hawthorn bushes. Here, wrapped in a thick cloak, she fell asleep; but the following morning when she looked out across the snowy white landscape she realised she was nonetheless still hopelessly lost.

Her salvation came thanks to the distant pealing of church bells. It was dawn, and she struggled through the snow in their direction, finally arriving in a state of near collapse at the door of the church from whence the noise had come. It turned out that this church was St Peter and St Paul's Church in Langham, and the bells had been rung for the Feast of the Conversion of St Paul. In gratitude for her deliverance the lady presented the church with a piece of land – the rent from which was to be given to the poor, and the hay from which was to be scattered around the church interior on St Peter's Day. The day ended well all round for the lady, since she was able to make her way to Oakham afterwards and nurse her father back to good health.

There is no date for this event; perhaps it dates to no earlier than 1974, when it was recorded by Susan Green in her *Further Legends of Leicestershire & Rutland* – although in all possibility the writer based it on elements of a much older local story she had heard.

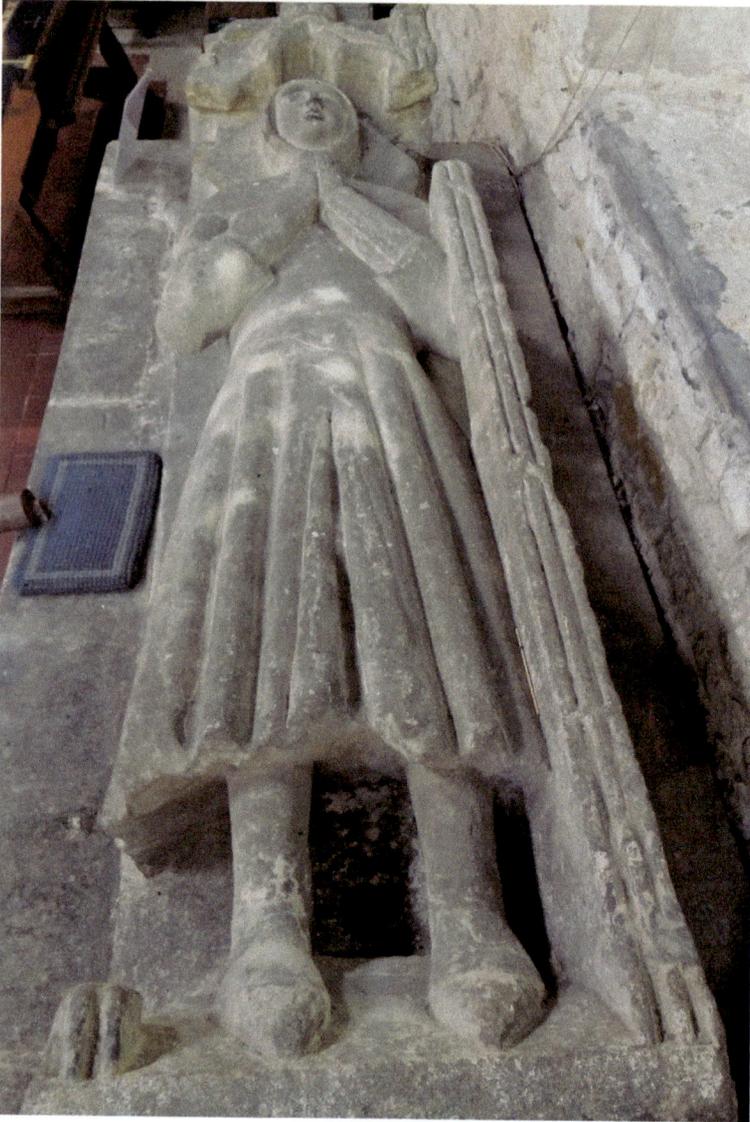

The Culpepper effigy.

Interestingly, there is a similar old story at South Luffenham. There, the bells of St Mary the Virgin's Church supposedly guided an elderly woman across the foggy common from Tixover. In gratitude, she donated around an acre of land called the 'Bell Ringing Close' whose income would pay the sexton to ring the bells at 5 a.m. and 8 p.m. daily from the end of October until 25 March. The day of the month was then tolled after each bell-ringing. The original Bell Ringing Close was near Foster's Bridge, but upon the field's enclosure in 1881 another field was allocated on the Morcott road. By the late 1930s the tradition of bell-ringing (known as the 'Curfew Bell') seems to have been struggling, however. This was due to a want of bell-ringers willing to rise at 5 a.m. and the payment having become considerably reduced.

The Bell Ringing Close used to host South Luffenham's village feast on the first Sunday after 15 August. It also used to be the custom to lean a sickle against the neck of the fourteenth-century Culpepper effigy in the church on the last Sunday in August.

Many churches in Rutland display old memorials evidencing beneficences bequeathed to the parish by those on their deathbeds – illustrative of how charitable the people of the county are. One of the most remarkable is in Manton's church: this is in memory of Penelope Smith, who died in 1727. Penelope was a nurse, and we are told that her charitable acts to 'thousands' of poor people made 'her loss universal to the British nation'.

Penelope Smith's memorial.

4. Notable Buildings and Characters

Secrets of Stoke Dry

Rarely does such a small place as Stoke Dry display so much intriguing, visible history. According to a plaque at nearby Eyebrook Reservoir, this water – straddling the border between Rutland and Leicestershire, and shining like a giant mirror – was used for low-flying practice by the Lancaster Bombers of 617 Squadron in preparation for the famous Dambuster raids on the Mohne and Edersee Dams in Germany in May 1943. However, it is at St Andrew's Church, a strangely disproportionate building with twelfth-century origins – that a wealth of curiosities can be discovered.

The remarkable church mural paintings have been dated to the 1280s by Mr Clive Rouse, who oversaw their revelation in 1972. A figure on the right depicts St Christopher carrying the Christ child on his shoulder; while that on the left depicts the martyred East Anglian king St Edmund tied to a tree and shot full of arrows by two bowmen. It has been

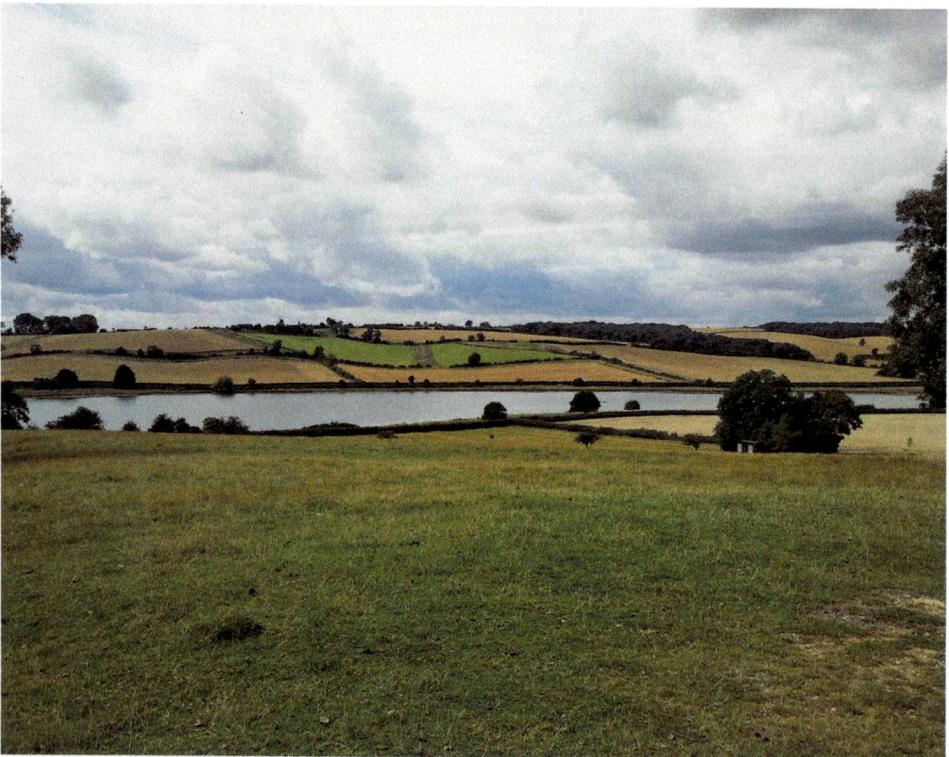

Eyebrook Reservoir, Rutland's 'other water'.

observed that the bowmen strongly resemble American Indians, with some American visitors reportedly being able to identify their exact tribe. This mysterious depiction has generated speculation that the murals represent evidence that Indian tribes were somehow widely known of in medieval Britain – 200 years before Columbus 'officially' discovered America.

On the floor of the chancel can be found an ancient memorial declaring, 'Here lieth the body of Dorothy Stevens, virgin aged XI, waiting for a joyfull resurrection, Novemb X 1637.' The stone pillars within the church are adorned with incredible carvings: among them fantastical animals, a cockerel-looking bird carrying a book (?), foliage, the Devil fleeing the sanctus bell, and people, including a detailed representation of a male bell-ringer. These have been dated to the late Norman period and the bell-ringer is thought to be one of the oldest depictions of this practice in the country, if not *the* oldest.

Propped against a wall elsewhere is a stone carving of a very elegant, beautiful lady dressed in a manner that looks medieval; one can only wonder who she may have been in life? At any rate, it is tantalising to speculate it may be the equivalent of a 'photograph' of someone from the era.

The Digby family associations with Stoke Dry are well known, as is the fact that Sir Everard Digby was executed in 1606 for his part in the Gunpowder Plot. The story of how the plotters met in the Priest's Room (parvis) above the porch, or even conceived their

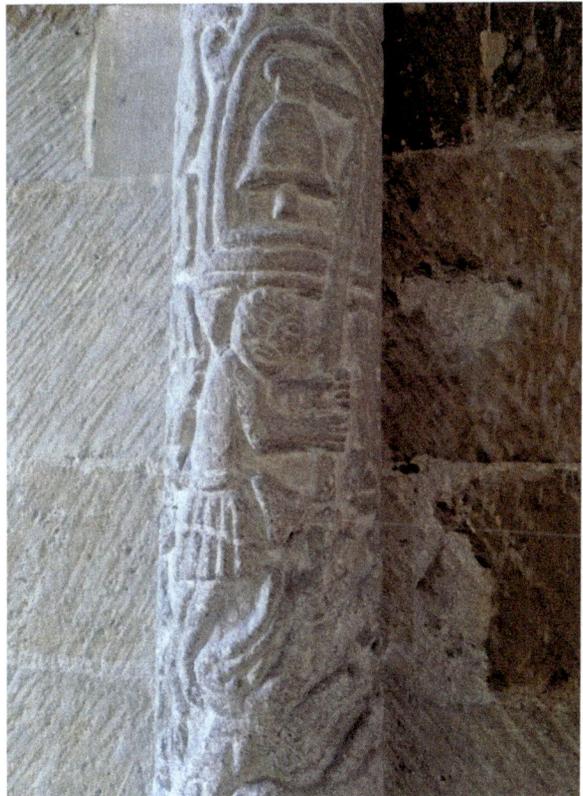

Stoke Dry's bell-ringer carving.

plan there, is probably untrue, since Sir Everard spent very little time at his manor here. Nonetheless, it is fascinating to ascend the thin spiral staircase to the room and contemplate what may have transpired here; especially given that the origins of the Gunpowder Plot are so vague. On a striking pair of Digby effigies, those of Kenelm Digby and his wife Anne, there can be observed a reddish discolouration. Interestingly, this author was told in February 2014 by fellow visitors to the church (a couple with their young son) of a popular belief that the Digby line had become 'stained with blood' through its associations with the Gunpowder Plot. Elsewhere, an alabaster portrait of Jacquetta Digby, who died in the 1490s, and her fourteen children, has been damaged, with the initials of the vandals carved into it.

In Stoke Dry's church, the more one looks, the more one sees; and it is so off the beaten track as to be generally hidden from public attention. It is without doubt one of the most intriguing places in Rutland.

DID YOU KNOW?
Simon de Langham was born in Langham around 1310. He grew up to be Chancellor of England and Archbishop of Canterbury, and is held to have been responsible for building St Peter and St Paul's Church in the village.

Who might have inspired this 'portrait' at Stoke Dry?

Newton's Sundial

It is a little-known fact that Market Overton has connections with the world-famous scientist Sir Isaac Newton. His mother, Hannah Ayscough, was born in the village in 1623, to James Ayscough, gentleman, and his wife Margaret.

A sundial on the exterior south corner of St Peter and St Paul's Church is believed to have been established there by Sir Isaac in recognition of his ancestry, and he may even have stayed here in his younger days. Perhaps more impressively, William White's *Gazetteer* explains: '[Hannah Ayscough] lived in an old house, where there is still to be seen on the ceiling of one of the rooms a drawing of a sun dial, supposed to have emanated from the same distinguished man.' The last we hear of this remarkable antiquity is in 1878, when a contributor to the *Grantham Journal* noted the house referred to had been pulled down and a modern one erected in its place. He concluded, 'Some relics of the former house are said to be preserved – in particular, the ceiling of a room in which Sir Isaac Newton is said to have drawn a sundial.'

Early examples of technology exist in Rutland, which would no doubt have fascinated Sir Isaac. Lyddington's St Andrew's Church has old earthenware jars built high into its walls, which were used as an aid to amplification – a primitive version of the loudspeaker. Back in Market Overton, Arthur Mee's *Leicestershire and Rutland* (1937) records the discovery of a holed saucer-shaped bronze vessel. When placed in water, the vessel gradually filled up and sank, taking almost exactly an hour to do so – leading to speculation it was a Saxon-era clepsydra, or 'water clock', designed to record time in the manner of a stopwatch or maybe even help tell the time. This now sits in Oakham's museum. One wonders what Sir Isaac might have made of that!

DID YOU KNOW?
Dean's Street, Oakham, was once called Dead Lane, due to coffins being taken via this route to All Saints' Church. It later became Dean's Lane as a reminder that the church and the area to the west once belonged to the Dean and Chapter of Westminster Abbey. In the wall of No. 1 Dean's Street is a panel inscribed 'S.C. 1682'.

Tod's Piece

Quite a tale exists as the explanation for Tod's Piece, an open area of recreation ground and allotments beside North East Street, Uppingham.

According to J. & A. E. Stokes's *Just Rutland*, Todd was a local mower who undertook a wager to mow a large area of grass with a scythe within a certain time. The town turned out to watch the challenge, and for hours Todd laboured doggedly until he could barely stand. By sundown the field lay all in swathes, and the bet was won. Unfortunately, though, Todd had exerted himself so much that in the moment of victory he collapsed and died before all present.

Tod's Piece, Uppingham.

A heritage trail board at the site explains that a John Todd, churchwarden, signed the parish registers in the 1630s, so the bet may have occurred around that time. The parish council acquired the land in 1928, and over the intervening years the ground where Todd laboured has been used for all manner of events, many of them sporting competitions – which one seems sure Todd himself would have heartily approved of.

The Mistletoe Bough

Exton Old Hall was an Elizabethan mansion of considerable proportions, and originally the seat of the Harington family. The hall's ruins – and indeed the parish – are steeped in visible history; for instance, one of the routes through nearby Tunneley Wood, Exton Park, is called the Queen of Bohemia's Ride, in honour of Princess Elizabeth, James I's daughter who later became Queen of Bohemia. As befitted the era, her life was a tumultuous one; but she is said to have been at her happiest riding through these woods in the early seventeenth century, when she dwelt for ten years under the hall's roof with Lord Harington, her guardian and tutor.

According to a well-known tale, an actress playing Juliet in an amateur performance of *Romeo and Juliet* at the Old Hall died of suffocation inside a large oak chest, where other actors had placed her after she had taken prop poison as part of the play. When the scene came for her to revive, cues went unanswered. The chest's heavy lid was opened by others, only to find her dead inside. This incident is supposed to have occurred one

Christmas in the early 1700s, with the actress often said to have been eighteen-year-old Katherine Noel, a daughter of the house. After the event, no more private theatricals were enacted at Exton. This grim event is also believed to have been the inspiration for the legend of the *Mistletoe Bough*, which gained popularity in literature and song in the early nineteenth century.

There are other stories. Subterranean passages supposedly led from the hall to the nearby church. Another legend concerns a grey horse owned by Baptist Noel, 3rd Viscount Campden, which during the civils wars of Charles I's time resisted all attempts to be brought under control by Parliamentarian troopers. Noel, a Royalist, was so stirred by the animal's perceived loyalty that he had a portrait produced of himself sat astride it.

Exton Old Hall was all but obliterated by a fire on 24 May 1810, which (as a matter of interest) spared the portrait by stopping behind the wall upon which it hung. Following the fire, a new hall was built a short distance away. Today, the sad, ruined shell of the Old Hall stands on the private land of Exton Park, although it can clearly be seen from the perimeter wall of St Peter and St Paul's Church. This should not deter the visitor, however, for the church is in itself well worth a visit. It is believed to date to the twelfth century, although it was much restored in the mid-nineteenth century following a catastrophic lightning strike that hit the spire on 25 April 1843. Moreover, the church contains nationally important monuments to both the Noel family and their predecessors, the Haringtons, as well as an even earlier monument to Nicholas Grene, who married

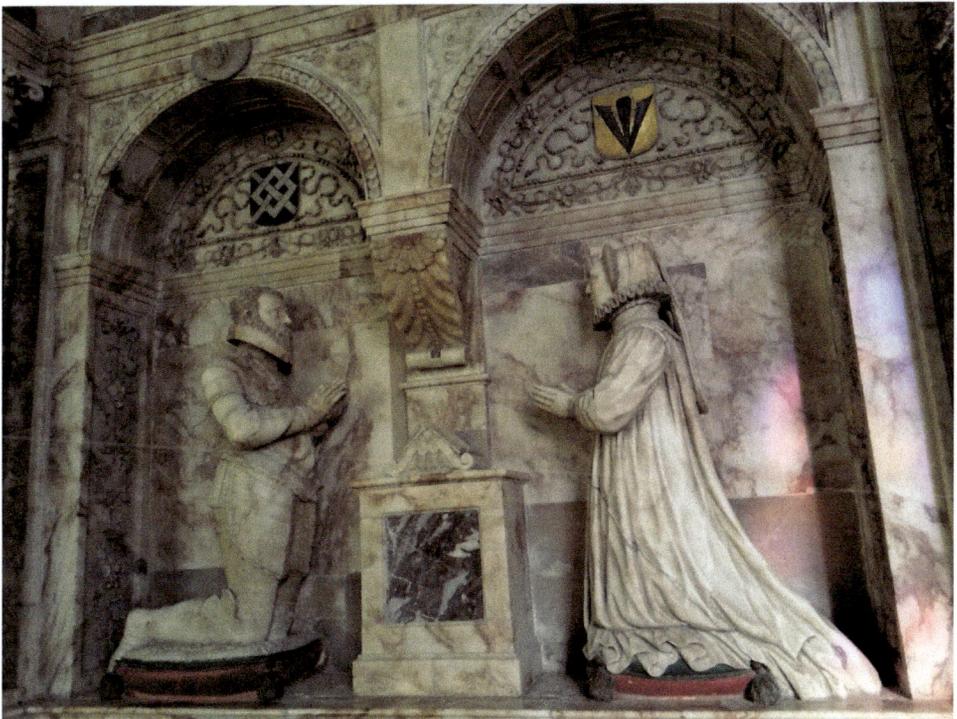

Magnificent monuments grace Exton's church.

into Exton's earliest landowning family, the de Brus. These spectacular monuments are at odds with the interment afforded to an unknown couple found dead in the snow within the parish boundary in the 1790s – they were merely buried in a pauper's grave on the north side of the church.

Wing's Wise Woman

According to a contributor to *Notes & Queries* in 1876, there had until recently lived at Wing (in a 'humble cottage') a Wise Woman called Amelia Woodcock. Amelia was not a witch; her skill was in healing and, although she had undertaken no formal training in medicine, her abilities are held to have been nothing short of miraculous.

Amelia was married to a common labouring man and began her career in healing by collecting herbs from the surrounding countryside, which she then made into medicines. As her reputation grew, patients daily came from so far afield in such numbers that Wing was frequently unable to accommodate them. Not only that, but medical men came to consult with her. Amelia later took to ordering drugs by the cartload from a chemist who had been formerly cured by her, rather than collecting herbs. At some point she relocated to Mount Pleasant, where she continued to ply her trade.

The periodical's correspondent remarked that she could 'treat and heal every variety of disease, including cancer'. Curiously, it seems Amelia did not possess the ability to cure herself, however, and she died at the relatively young age of forty-seven in 1863. She was interred at Hambleton. *The Villages of Rutland* (Vol. I, Part II) reports a cruel rumour afterwards developed saying Amelia killed herself because people called her a witch. Her obituary in the *Stamford Mercury* in fact suggests she may have died through overwork.

Amelia lived in a cottage in City Yard, Wing, which may have earned its name because of the 'city folk' who came to see her. It appears it was only pulled down in 1975. I also understand that medicines based on her remedies were being sold in Rutland chemists as late as the 1950s.

DID YOU KNOW?
A public path along the eastern shore of Fort Henry Lake, Exton Park, affords amazing views across the water of Fort Henry. Sitting directly on the shoreline, the building is a castellated pleasure house built as a Gothic folly in the 1780s for Henry, Earl of Gainsborough.

The Ram Jam

For centuries the Ram Jam public house has been a familiar sight to those who travelled along the Great North Road, although originally it was never much more than a humble beerhouse, where coaches changed their horses. It rarely sheltered guests other than cattle drovers. At one time its name was the Winchilsea Arms, and it bore no other sign than the armorial shield of the Earls of Winchilsea. However, its fame increased around 1740, when

the landlord – an officer's servant called Charles Blake (d. 5 March 1791, aged eighty) – returned to Rutland with the secret of compounding a liqueur called 'Ram Jam', possibly a term he had picked up while in India. The drink proved very popular, and although the method of making Ram Jam was passed to his son, the knowledge was lost by the early 1800s and the drink ceased to be sold.

By 1813, the Winchilsea had long gone by a different name connected with this secret recipe, with one gazetteer of the time noting: 'On the high road side is the well known "Ram Jam Inn", which has long been a house of call for the coaches on the great north road, though nothing better than a lone public house.'

The Ram Jam possessed another story concerning its name change, a version of which almost everyone in Rutland must be at least vaguely familiar with. Broadly speaking, in the days of highwaymen, one such rogue took the landlord (or landlady) down to the cellar. Using a persuasive argument that it was possible for two sorts of beer to be drawn from the same barrel, he deceived the landlord into ramming one thumb and jamming the other into two holes they drilled on either side of the barrel. With the landlord immobilised because he was unwilling to withdraw his thumbs and let the ale pour out, the highwayman simply fled without paying his bill. Other versions say the scam was perpetrated so the villain could seduce the landlord's wife, or daughter. The scam is also said to have been perpetrated by the infamous house-robber and highwayman Richard Turpin.

This stretch of the Great North Road does seem to have been the haunt of highwaymen in the 1700s. In 1873, Edward Bradley, Stretton's rector, was present when human bones were dug up opposite the Ram Jam. Local opinion had it that they were the remains of a packman murdered at the inn many years earlier, who was secretly buried at the roadside.

Incidentally, the inn was where the American prize-fighter Tom Molyneaux stayed the night before his legendary bare-knuckled heavyweight boxing match with Bristolian Tom Cribb. This gruelling battle occurred on 28 September 1811 at Thistleton Gap, a Rutland copse bordering both Leicestershire and Lincolnshire. The location was chosen in case the police raided the event, in which case the 15,000 spectators present could flee across county boundaries. After twenty minutes spent pounding each other, Cribb broke his opponent's jaw in the eleventh round and claimed victory. The fight accounts for the name of Cribb's Meadow, a nearby national nature reserve.

The Ram Jam enjoyed something of a renaissance in the twentieth century. The building itself has been developed and added to, and in 1953 J. & A. E. Stokes's *Just Rutland* called it an 'old coach house that has become an imposing road-house'. They even observed a stone panel over the main doorway depicting the Cribb vs Molyneaux fight – believed to be the work of a spectator at the ringside. (This is now in Oakham's museum.) The inn's fortunes have waxed and waned over recent years, including a fire it suffered around thirty years ago. Today the Ram Jam still stands by the Great North Road, but at the time of writing (2018) it presents a sad reflection of its former self: for it is now empty, boarded up and gradually becoming screened from the Great North Road's heavy traffic by unattended foliage. However, anyone who cares to explore the exterior will discover the inn's old pub sign – with its faded pastel colours – depicting an image of the landlady with her fingers stuck in the beer barrel, while the trickster flees out the door, bidding her *adieu*. One wonders if it is an original: there is mention in the *Grantham Journal* (23 September 1882)

The Ram Jam's faded sign.

of the sign of the Ram Jam Inn only recently having been displayed in September 1879. Prior to this, the Winchilsea Arms sign still hung, although it seems fairly evident the place had been commonly called the Ram Jam for decades.

Rutland ends just beyond the Ram Jam. Sadly, at the time of writing, the inn's future looks uncertain.

DID YOU KNOW?
In 1895, a circus passed through Glaston on its way to Uppingham and a curious elephant fell down a well situated on the roadside against the Grange Farmhouse wall. It was eventually recovered. (The well no longer exists.)

The 'Peasant Poet'

John Clare, the Northamptonshire 'peasant poet', at one time worked as a limeburner at Pickworth. The church ruins there inspired one of his early poems, written one Sunday morning in 1818 after he had been digging the hole for a limekiln. His future wife, Martha

Turner, lived at nearby Walk Farm. Clare fell in love the second he set eyes on her – he even climbed a tree to get a better view of her walking through fields.

South Luffenham's Windmill

Isolated in the middle of a field beside Station Road, there can be seen the shell of South Luffenham's former windmill.

The average motorist may not pay much notice to this derelict building at first glance, although its heritage is impressive nonetheless. It dates to 1832, when the erection of a tower windmill was first proposed in the local press, and it functioned throughout the nineteenth century. In the spring of 1895 tremendous gales tore off the cap, although the building continued to be used until 1908 – when its cessation turned it into the ruin we see now. The windmill is intriguing not only because it is multistorey and very photogenic (sitting on a gentle slope between the two Luffenhams), but also because it is another windswept ghost of Rutland's past industry.

South Luffenham was famous at one time for the mills in its vicinity. It also anciently sustained a Tudor watermill and horsemill, an early nineteenth-century watermill and a steam and electric mill (c. 1892). But the multistorey windmill, roofless and floorless, is perhaps the most captivating reminder of a local means of employment our great-grandfathers would have taken for granted only four or five generations ago. (The land the windmill stands upon is now private.)

The windmill, from Station Road.

Lady Charlotte Finch

In 1813 the newspapers respectfully reported the death on 11 July of Lady Charlotte Finch, aged eighty-nine. In 1762 she had been elevated to the important position of governess to the royal nursery and became responsible for looking after the children of George III. Among other things she is often credited with helping invent jigsaw puzzles for children.

Lady Charlotte died in London and was buried in Buckinghamshire. Her actual connections with Rutland are minimal, being largely through her son, George. George Finch inherited the estate at Burley-on-the-Hill and title of 9th Earl of Winchilsea following the death of his childless uncle in 1769.

The earl had a marble sculpture made in his mother's memory. This was completed in 1820 by Sir Francis Chantrey and can now be found in Burley's church. It is often stated that, somehow, in a building full of antiquities and history, it is Lady Charlotte's sculpture that dominates and draws people towards it. This is perhaps because of its symbolism rather than its being an actual representation of her, and also because the sculpture appears almost ghostly in a dark grotto-like corner of the church.

Gothic, beautiful and somehow strangely melancholic, the sculpture is a testament to George Finch's veneration of his mother and acknowledgement of her services to the royal family.

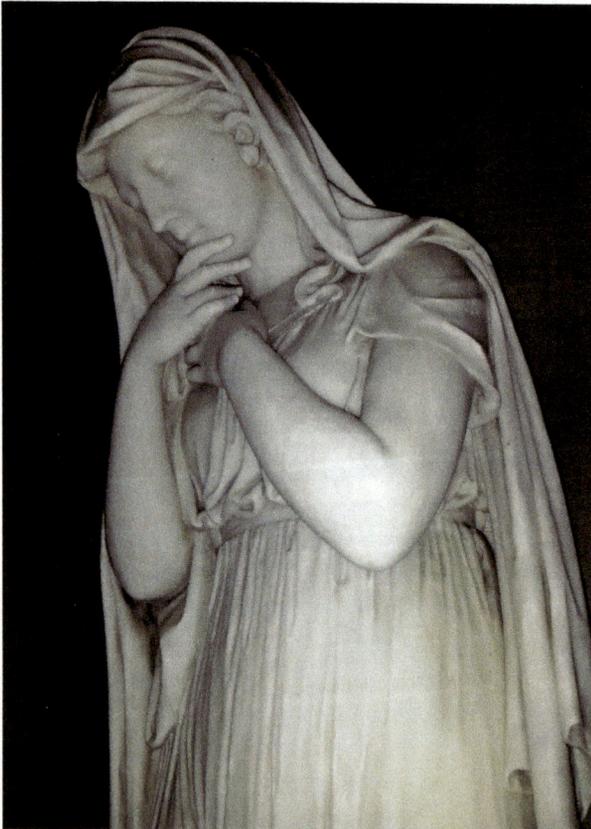

Lady Charlotte's sculpture.

Churchill in Rutland

Burley House, having been obliterated once by Parliamentary soldiers who set it on fire during a siege in the Civil War, suffered another disastrous fire on 9 August 1908. One of the guests was Winston Churchill, who re-entered the burning property repeatedly to preserve valuable artefacts: during one attempt, he narrowly escaped being killed when a roof fell in from a height of 60 feet. One policeman present reportedly said afterwards, 'Everyone recognised in him a leader.'

DID YOU KNOW?
The Hollywood actor Hugh Jackman briefly worked as a teaching assistant at Uppingham School in 1987; while one Old Uppinghamian is *Blackadder* and *QI* star Stephen Fry – who was famously expelled in 1972.

This memorial in Manton's church to Robert Heathcote, a landowner of Manton Hall, contains a thought-provoking final message.

5. Crime and Misdemeanour

Law and Order

Although the county assizes were famously held at Oakham, it seems that in the past Tinwell also had a role in crime prevention. In 1727 the Stamford historian Francis Peck noted that, between Tinwell and Stamford and not far from 'a mill of great antiquity, called King's Mill', there had once stood Bredcroft House. Here, the sessions for Rutland were anciently held.

The assizes there supposedly occurred around Henry VIII's time and were possibly connected with Stamford's sessions in some manner. Those convicted were hanged on a gallows between Tinwell Heath and Empingham Road.

The sessions house seems to have stood in the vicinity of the weir and the Stamford Spa, where the ancient village of Bredcroft (named from its bakers' ovens) once thrived half a mile west of Stamford. Peck recorded that Bredcroft's hall stood on the northern

This restored warning sign to vagrants (on a private dwelling in Barrow) was originally put up in the seventeenth century.

bank of the watercourse, but even by his time only the foundations remained. Nowadays nothing can be found, although the explorer may still find the riverside walk a rewarding one, provided they are not bothered by the incessant roar of A1 traffic.

In South Luffenham, according to *The Villages of Rutland* (Vol. I, Part II), a gallows also stood on the Common, approached by a track called Hangman's Lane. The gallows, it seems, was a local deterrent set up to discourage the poor of the parish who congregated there, stealing wood and feeding their livestock. The Common covered a wide area to the east of the village.

A Parent's Deadly Error

On or around Sunday 8 March 1752 (as was reported in the *Gentleman's Magazine*) an awful tragedy occurred in 'Barronden' (i.e. Barrowden).

Edward Munton, farmer and grazier of that place, purchased some medicine for his children. He thereafter purchased some 'rats-bane to make sheep-water', and notwithstanding the apothecary's advice to keep the two packets entirely separate Munton handed both to his wife without informing her they contained different substances. Of course, being unaware, she mixed the rat poison into some treacle, which she then served to the children. By 11 a.m. that morning 'two fine girls and a boy' had died writhing in agony, and the two eldest boys had joined the list of fatalities by 3 p.m.

All were buried in one grave on 9 March – the awful irony being that the Muntons had intended to encourage the health of their children by getting them to take physic hidden in treacle, yet ended up killing all of them through carelessness.

Bowland's Gibbet

For decades, on the edge of the Great North Road, near Tickencote Warren, the body of an executed felon hung, bound with iron straps, from a gibbet post in full view of all who passed by this way.

The criminal was twenty-six-year-old John Bowland. Although he bore a reputation as an honest tradesman, Bowland had turned to highway robbery and was eventually arrested in Greenwich as he tried to flee the country. Bowland would have escaped were it not for the fact that he delayed sailing to dance all night at an event, enchanted by the mention of his name in some of the newspapers. He was convicted at Oakham Assizes of robbing the North Mail near Bloody Oaks in March 1769 and sentenced to death; and at 9 a.m. on 20 July he was hanged at Oakham. The papers reported at the time how his cadaver was hung near Horne Lane (Ermine Street) as a permanent warning to any other people thinking of committing robberies on this stretch of road.

In 1879 'Cuthbert Bede' (otherwise the aforementioned Edward Bradley), a collector of traditions, commented: 'An old post-boy once told me, that the last he saw of the gibbet was when it had been taken down and flung into the ditch, on the other side of the road, at the Bloody Oaks corner of Horne Lane.' The gibbet post seems to have stood near a century as in 1867 a visitor recorded: 'The man who pointed out the scene of the battle (of Losecoat) to me seemed to think it insignificant beside the post of a gibbet, which until last year stood close by.' Some accounts suggest the post's stump may have still been standing as late as 1900. When Bowland's cadaver disappeared from the post is unknown.

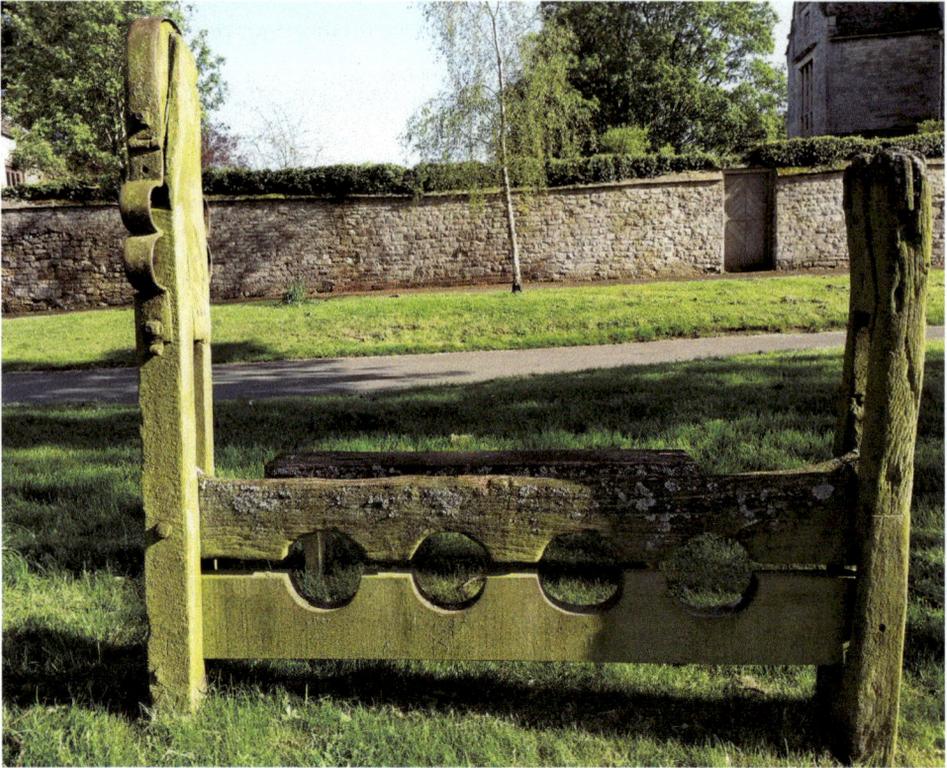

Market Overton's stocks, last used in 1838, are preserved on the village green. Left upright was also a whipping post.

The Site of Rutland's Most Infamous Crime

At the corner of High Street and Gaol Street, Oakham, there once stood the old gaol and bridewell. Oakham Gaol appears to have been a two-storeyed thatched building dating to the late 1400s, with its premises incorporating courtyards and a gaoler's house that fronted onto High Street. In the late eighteenth century it was the site of what has perhaps become Rutland's most notorious killing.

On 16 November 1788 a local baker called John Freeman, returning from Oakham's market, was ambushed by robbers in the lane between Nether Hambleton and Edith Weston. His attackers beat him to death with a heavy stick and a pitchfork, leaving him to be found the following day, after making an attempt to drag the body off the road. One of the first people questioned was twenty-five-year-old William Weldon, a native of Nether Hambleton employed as a shepherd who bore an unsavoury reputation. The young man was terrified when brought before a magistrate at Empingham (Reverend Foster) and he implicated his brother Richard. Richard was swiftly arrested in Huntingdonshire after cashing a bank post-bill stolen from the victim.

The brothers were imprisoned in Oakham Gaol. On the afternoon of 8 February 1789 the gaoler Henry Lumley entered their cell to pray with them. Unbeknown to Lumley, Richard Weldon had managed to saw off his leg irons using an almost-blunt knife given

to him for peeling potatoes. He then battered Lumley on the head with a heavy stick that he had hidden behind the cell door.

Richard Weldon proceeded to roam the gaol at will, crossing the yard and entering Lumley's residence. Mrs Lumley and her mother were actually at home when Weldon came in, but – during what must have been a terrifying experience – they concealed themselves behind a screen while Weldon rummaged the house looking for keys. While Weldon was upstairs, Mrs Lumley screamed for help from some neighbours, who secured the murderer as he came back down the staircase.

The injured gaoler died the following morning. William and Richard Weldon were tried at Oakham before Baron Thompson on 14 March, and convicted of murder. Two days later, the brothers were hanged at Mount Pleasant, just south of Swooning Bridge (the name of which, according to one explanation, being on account of the women who fainted there during various executions). Before he died Richard Weldon confessed his intention to commit a general slaughter within the gaol and then around Hambleton before he was retaken. According to the recollections of Dick Christian of Cottesmore, who saw the executions when a boy, both died wearing white caps, and Richard ('a regular hardened one') kicked his shoes into the crowd to prove his mother wrong about him dying with his boots on.

The gaol stood at the top of this street, on the left.

The brothers' corpses were afterwards hung in chains from a gibbet post on Hambleton Hill as a warning. This is the reason why Edith Weston has a Gibbet Lane, which leads to Gibbet Gorse – now the place where Rutland Water Golf Course is situated. Eventually, both corpses 'hung till they fell down'. The gibbet post was dismantled around 1845. The Weldon's parents' house in Lower Hambleton – from which they could see their sons' cadavers hanging on the gorse – stood until around 1830.

Another tragedy, symptomatic of the times, occurred in the gaol a few years later. In March 1793 a young woman, Mary Scott, delivered a baby boy in Empingham, immediately cutting the child's throat after giving birth. Mary was arrested, as was her mother as an accomplice, although the latter was released upon Mary's assurance she had acted alone. She died two months later in Oakham Gaol.

The ancient gaol was pulled down and replaced in the early 1800s, when the New County Gaol was built at the junction of Station Road and Kilburn Road. Owing to a lack of inmates this new prison was closed in 1878 and prisoners thereafter committed to Leicester. I understand that houses were built on the site of the old gaol, with the cell doors incorporated into the dwellings as front doors! This site is now where the Co-op is.

DID YOU KNOW?
Sarah White, of Braunston, accused of forcibly drowning her child in a wash-pond near Oakham, was discharged at the August 1817 assizes. Why? An objection was raised that the word 'feloniously' had been omitted when she was charged, which was necessary in law to capitally convict her.

The New Drop Gallows

Within Rutland County Museum there is a unique and grim reminder of the days when death sentences were imposed at the assizes. This is the county's 'New Drop' gallows, a portable contraption with a hinged platform-type affair used in the early nineteenth century to hang felons in front of the New County Gaol, and believed to be the only remaining example of its kind left in the UK. Despite its progressive-sounding name, however, the gallows were not especially effective, the drop being too short to snap the subject's neck cleanly.

Prior to the introduction of the New Drop gallows, felons had been publically executed at Mount Pleasant in front of enormous crowds. That capital offences were committed rarely in Rutland is implied from a report in the *Derby Mercury* in January 1737, which noted, 'We hear from Oakham in Rutland, that last week a man was committed to their jail for a robbery on the highway. It is remarkable, that not one person has been hanged there for near 18 years past.' The man who ruined this enviable record was James Watson, who was sentenced to death at Oakham Assizes and hanged that March for several robberies.

Site of the New County Gaol today.

Watson's fate did not deter others and more highwaymen followed him to the gallows in 1758 and 1760 following their convictions at Oakham Assizes. Since such hangings were rare in Rutland one can imagine the ghoulish excitement these public spectacles created, and thousands would turn out to watch such deaths at Mount Pleasant.

There is little doubt that the execution that created the greatest stir was that of John Swanson, for his crime was of a barbaric and unparalleled nature. Swanson was arrested in 1758 following the brutal murder and mutilation of two aged cottagers, Anne Woods and Robert Broome, at 'Hambleton-on-the-Hill'. The killings stemmed from a row over the rights to cut hedges, but Swanson's excesses in committing the murders caused much controversy over his state of mental health: he made no attempt to avoid detection, and when he was apprehended the hearts of both victims and Mr Broome's head were found concealed in a chest under his bed. He was initially incarcerated in St Andrew's Church, next to the mutilated cadavers of his two victims.

Swanson was sentenced to death at Oakham Assizes and hanged on 12 March 1759, although his body was not gibbeted. The distinction of being the last people to be gibbeted in Rutland went to the Weldon brothers (see elsewhere). Swanson's body was transported to Stamford, where it was dissected and anatomised by surgeons. The gallows on which these people were hanged at Mount Pleasant was a permanent structure and remained in place as a warning until around 1860, even when replaced by the portable 'New Drop' gallows.

The New Drop gallows were first used in 1813. At around 11.30 a.m. on 5 April that year, two men – John Holmes and William Almond – were brought out onto the gallows platform in front of Oakham's new gaol in front of a vast concourse of people. Both had been convicted at the previous Rutland County Assizes of a robbery at the house of Revd Lucas in Great Casterton. The *Stamford Mercury* reported their demise in detail:

> Extreme agitation worked upon their frames and features, but the sparkles of a better hope were plainly visible, and they repeatedly declared that they were comfortable and at peace with all men. A few minutes after twelve, the supporters of the platform on which the unfortunate men stood were knocked away, and they had soon passed the ordeal of human suffering. Almond appeared to be insensible of pain after the lapse of a few seconds, but Holmes struggled on the brink of eternity for *a minute or two.*

After the two bodies had hung lifeless for some time, they were cut down. Holmes's body was delivered over to friends; Almond, we learn, was interred in Oakham churchyard. A third participant in the robbery, one Millington, was reprieved, but forced to watch the melancholy exit of his two companions from the gaol window – one can only wonder what was going through his mind and what lessons he learned from his narrow escape from death.

According to the reminiscences of an 'Old Boy' (possibly a pseudonym for Robert Wade-Gery) published in the *Oakham School Magazine* for 1892, some of the town's young scholars were taken on a day out and treated to the sight of the double hanging in 1813:

> One of my earliest recollections is the execution of two poor fellows for housebreaking. Dr Doncaster, thinking that the little boys, of whom I was one, might get into mischief or some accident befall them, sent us all to the jail ... that we might see the shocking sight without danger. Perhaps the good doctor was right in letting us go, for it certainly made a serious impression upon some of us. I remember to this day the Psalm tune which they sang, as they came up to the scaffold...

The gallows were used sparingly in the years that followed, hanging two convicted rapists in 1824 and 1826. It was last used in 1833 to hang John Perkins, a twenty-six-year-old Ketton stonemason who had been convicted of shooting a gamekeeper during a poaching expedition in Empingham Old Wood. Thomas Peach, the victim, was lucky not to have died, and Perkins was hanged for his offence on 25 March 1833. Perkins was condemned on the evidence of an associate called Claypole, who was afterwards run out of Easton (where he lived) following a campaign of abuse and vandalism against his house.

The New Drop gallows in Oakham's museum is the very instrument used to execute Perkins and several others before him. Thankfully, it was not needed again. In 1973 its dismantled components were presented to Oakham's museum by Mr J. E. Smith, who had a lifelong connection with Oakham Castle. Also presented were other artefacts connected to the gaol and courts held at the castle, such as handcuffs, immobilising leg irons, pistols and cutlasses. Schoolchildren are sometimes brought to the museum to

Oakham's gallows look like they might still work...

see the contraption – although thankfully today there are no bodies swinging from the sturdy beam for them to behold when this grim reminder of Rutland's past is presented before them.

Burley Wood Poaching Affray

Even at the time many guidebooks to Rutland described the county as having enviably low crime rates, with the violent crimes that did occur seeming to be peculiarly rural. Take, for instance, the case of Thomas Clarke, who in 1853 struck fellow beast driver Thomas Ward with a pitchfork during a violent argument in the parish of Wardley. Ward died and Clarke received four months' imprisonment for manslaughter. Ward's grave in Wardley's churchyard is held to have had the inscription 'Slain by a vicious enemy' chiselled on it, although it appears to no longer be there.

Rutland, however, did suffer greatly from poaching – perhaps the nearest thing to organised crime in the county.

Burley Wood, the extensive woodland that borders Burley House, was the setting for a vicious clash in 1884. Between the hours of midnight and 1 a.m. on Saturday 9 November the gamekeepers for Mr G. H. Finch, MP for Rutland, encountered six or seven poachers from Nottinghamshire and Leicestershire busily engaged in netting rabbits at the bottom end of the wood. It appears the gamekeepers had prior intelligence that such a gang would be active, but when they surprised them the poachers immediately turned on them and attacked them.

A terrible battle ensued. One of the keepers, a man named William Collier, took a dreadful beating, and upon one of the poachers advancing to further attack him, Collier struck the man violently twice on the head with a heavy stick he carried. Such was the force of his strike that the man dropped down at his feet. The seriousness of the injury appeared to lessen the resolve of the other poachers, two of whom were arrested. The others fled into the darkness of the trees. After the clash a mass of netting was discovered that contained fifty-six trapped rabbits.

The injured man was taken to the Keeper's Lodge, where – his skull having been fractured – he died shortly thereafter. He proved to be one Robert Baker, a shoemaker's apprentice from Melton Mowbray. A hastily arraigned coroner's inquest at the lodge brought in a verdict of 'Justifiable Homicide' when it was recognised that Collier had been acting in self-defence and had feared being murdered.

The slain man was interred in Oakham cemetery. The two who were apprehended during the clash were James Elenor of Upper Broughton and Richard Tallis of Oakham. Both admitted they had come by train (along with the deceased) with the specific intention of poaching, but denied there were any other fellow poachers involved in the incident. They were equally hastily committed for trial at Oakham Castle and sentenced to three months in gaol – the whole proceedings being over and done with within four days of Baker's death.

The Keeper's Lodge, where the dying man was taken, was situated near Burley Fishponds, which sat at the end of the house's wooded South Avenue. Burley Fishponds are now submerged under Rutland Water and only reveal themselves when the water is at low level. In April 1906 a woman called Elizabeth Cutforth drowned her two children – a toddler

and a baby – in the ponds, before attempting suicide. She was dragged out the water by passers-by, but later died of pneumonia.

DID YOU KNOW?
William White's 1846 *Gazetteer of Rutland* noted the mysterious discovery 'a few years ago' of a stone coffin buried in a hill near St Luke's Church, Tixover. It contained nothing except 'a few perfect teeth'.

A Mysterious Suicide

Around midday on 26 January 1884 John Christian, farmer and grazier of Barrow, shocked the community with his unexpected suicide.

The event was somewhat mysterious. That morning Mr Christian had appeared in good spirits, dressing for a trip to Oakham and asking if his horse was harnessed. Around 12.35, however, he was discovered writhing in agony in the stables. When his eyes fell upon his wife's char, Mary Simmonds, he said her name several times and then asked for a doctor to be brought to him. In front of two independent witnesses he issued a bizarre warning: to have no connections with church parsons, 'because they have broken my heart'. Mr Christian died just over an hour later, aged in his late fifties. His face was blue and as he died Christian gasped that he had poisoned himself with laudanum.

Although his family were aghast and mystified a coroner's jury decided he had committed suicide 'while temporarily insane'. Although there is some suggestion Mr Christian was mired in financial complications (he appears to have had both creditors and debtors), the true reason why he took such drastic action – apparently unwillingly – remained a secret.

The Christian family had lived at Barrow for generations until this event. There is also a story that in the eighteenth century John Christian, about to inherit the estate, rode to Glebe Farm (near Rogue's Lane, Cottesmore) to survey the land that would become his. In front of his family and employees he said, 'Tomorrow at midday these 1,000 acres will be mine', before sliding off his horse, quite dead, having expired at that exact moment.

'A Rutlandshire Tragedy'

From 1890 what is now Kimball Close, between Oakham and Ashwell, was where the Cottesmore Hunt's hounds were kennelled, and it is here that a widely reported murder occurred in 1896.

In the small hours of 6 September two stablemen, Francis Rodgers and Charles Packer, started to argue after having returned from Oakham following separate evenings out. Both were apparently the worse for drink and when Rodgers pushed Packer he fell off his seat in the mess room. Rodgers next snatched up a heavy poker from the fireplace and dashed Packer three times on the skull with it, killing him instantly. The victim was aged thirty-five when he died. The police were very quickly on the scene and Rodgers was

taken to Oakham Police Station, having apparently sat and waited to be arrested. That evening Rodgers attempted to commit suicide by hanging himself from his cell window bars, but was discovered before he expired. It was reported that a large crowd harangued the prisoner during one appearance before a magistrate.

When Rodgers, aged forty-two, went on trial at Leicester Assizes, his conviction was assured since he had commented after his arrest that he had 'knocked [Packer] into the middle of next week'. Rodgers, who was Irish, had also stated, 'I'll die like a true-born Irishman.'

Rodgers was sentenced to be executed on 10 December, but this never occurred. The jury recommended mercy, citing extreme provocation and drunkenness, and the killer was reprieved before the death date. His sentence was commuted to one of penal servitude for life.

At one time the Cottesmore Hunt buildings here housed 100 hounds, fifty horses and forty grooms and stablemen. In 2004, however, they were developed into residential housing, with Kimball Close taking its name from Baron Kimball, a former Rutland County Councillor. The original buildings are still there, though, and the prominent rooftop clock displays a weathervane shaped like a fox – for obvious reasons.

An article on crime in Rutland in the *Daily Mirror* in 1945 (calling it a 'crimeless county') remarked there had not been a murder so far that century. This is not quite true of today; sadly, appalling crimes and horrific murders have occurred in recent memory, although such incidents are still comparatively rare in Rutland.

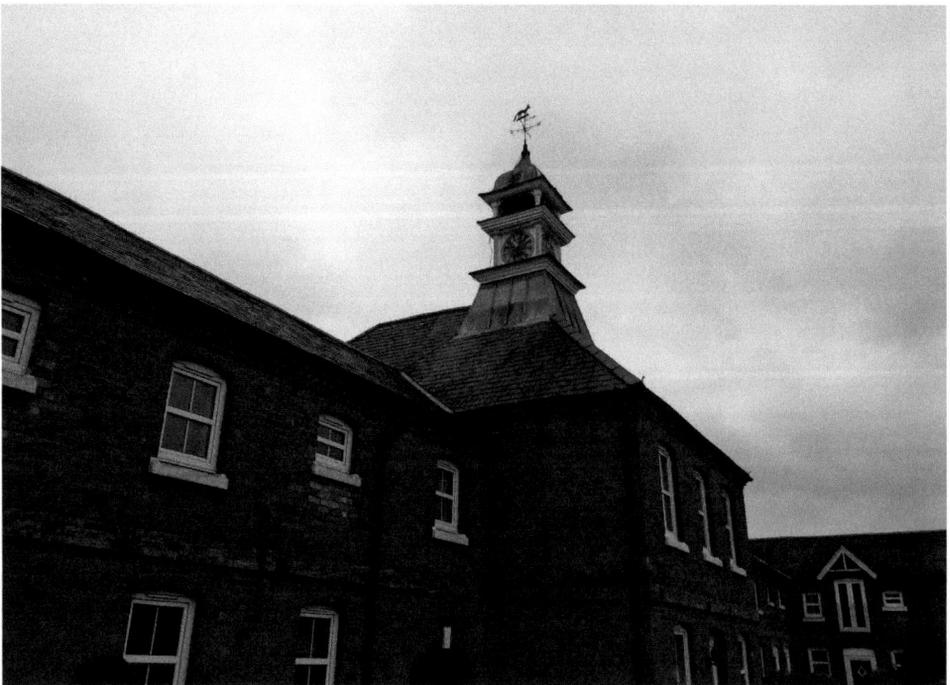

The site of the killing today.

6. Antiquities and Curiosities

The Braunston 'Goddess'
If one walks up the path to All Saints' Church in Braunston, past the ornate windows, and looks at the rear of the building, they will discover a stone carving that is considered one of Rutland's most remarkable curiosities.

Cemented to the wall is a 3-foot-or-so-tall gargoyle-like figure that clearly displays human characteristics, although grotesque. However, the figure is not believed to be a gargoyle, but is in actual fact thought by many to be a 2,000-year-old representation of a Celtic earth mother. According to *Folklore, Myths and Legends of Britain* (Reader's Digest, 1973), 'It is thought to represent a goddess who was worshipped in primitive fertility rites which took place on the site of the church in pre-Christian times.'

If this is true, then Braunston's 'goddess' is possibly unique and it is remarkable that she has stayed in one place for so long. During a visit to see her in February 2014 I was told by a Sunday worshipper that the figure was 'definitely not' a gargoyle, and was thought to have been found – face down and being used as the church porch's doorstep – during renovation work at All Saints' sometime in the early 1900s. There is perhaps a greater danger to her now from the elements than there ever was before when she functioned as a doorstep.

That the figure appears to be some kind of fertility symbol may be inferred from her prominent, cartoon-like breasts and lips. Be that as it may, she now commonly goes by the name of the Braunston Goddess. She certainly does have a uniquely curious allure of her own, despite her appearance. The person who carved her all those centuries ago was extremely skilled, possessing the goddess with characteristics that ensured she looked human and yet not human at the same time.

In the interests of even-handedness some consider her to date to no earlier than the thirteenth century. But, if the stories are true, she was gazed upon with superstitious awe two millennia ago. I was also told that today people wishing to conceive will touch the stone figure as though for its blessing.

The Maze at Wing
In the village of Wing, beside Glaston Road and near the recreation ground, an antiquity can be found that sheds some light on how people in days gone by passed their time.

This is where a maze can be sought out, although it is not of the type to engage the attention of children – it is cut into the turf rather than consisting of tall hedges. The maze is circular and around 40 feet (12 metres) in diameter, consisting of a single grass path that winds and backtracks concentrically until the middle of the circle is reached. Thus the maze is more correctly a labyrinth. Today the whole circle is surrounded by a small, modern white-picket fence.

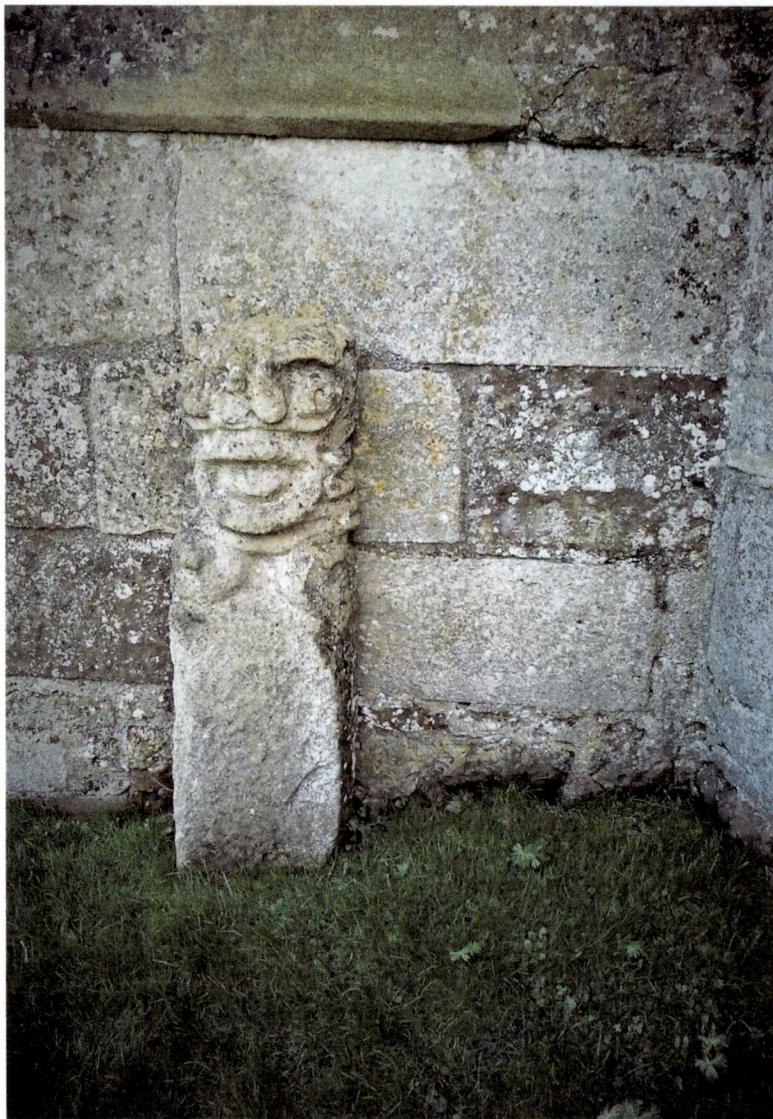

Braunston's 'goddess'.

The age of the maze is unknown, since there is no way of dating such landmarks. An educated guess, however, would place it as being medieval in origin. As to its use, there are a number of theories. Following the crusades people may have walked around the maze – possibly on their knees – as part of a spiritual rite. There is also a tradition that one of its original uses was as a 'walk of shame' inflicted by the Church upon wrongdoers, and therefore it functioned as a form of penance; it is certainly possible that a local monastery was involved in its construction. However, by Tudor times it is likely the maze was being used more for fun, and this certainly appears to have been the case by the nineteenth century: the *Leicester and Rutland Directory* (1846) describes it as 'an ancient maze, in which the rustics run at the parish feast'. At any rate, it seems to have been a

Wing's ancient turf maze.

focal point in Wing for centuries, and it is easy to imagine the yells of delighted children from generations ago as they ran around it. The siting of the modern recreation ground nearby seems particularly apt if this was the case.

According to *Leicestershire and Rutland Notes and Queries* (Vol. III, 1895), 'There is a tradition at Wing respecting the maze there that it was cut by a blind shepherd. It is well cared for.'

There is also a dubious tradition that at one time a roosting cuckoo would be penned in the maze in a symbolic effort to keep spring eternal; however, this was simply folly, for the bird merely flew off. There is a reference to this in J. M. Neale's *The Church Tourists* (1843) in which he notes, 'I shall not forget the maze in which the Wing fools tried to snare the cuckoo; nor the clamour which the question, "Who tried to hedge the bird?" still excites among them.'

The Wing maze is one of only eight left in England. It is possible, however, there was also one on Priestly Hill, Lyddington, for John Dudley's 1846 *Naology* mentions a maze being cut 'some years ago' there. A contributor to the *Rutland Magazine* stated in 1907 that local old people recalled it as a 'turf maze' where their grandparents used to play. One wonders whether this was a genuine maze or a misidentification of the ancient fish ponds belonging to the Bishop's Palace, however.

The Cross-Legged Knight

In St Mary's Church, Ashwell, there is a very special – and curious – memorial. Believed to date to the early fourteenth century, it takes the form of a recumbent knight clad in a coat of armour. One leg is crossed behind the other, signifying the deceased had taken part in two crusades (some think three, however), and the feet rest upon a lion. This altar-tomb is doubly remarkable in that it has been carved out of the trunk of a tree and is hollow.

Who the effigy represents isn't known for sure, although he was probably one of the Tuchets who left Ashwell to fight in the crusades in the late 1200s – perhaps Thomas Tuchet, who died around 1 May 1315. By that time the Tuchet family had possessed the manor of Ashwell for around 230 years.

The effigy is in a remarkably good state of preservation for something so ancient. Today, it can be found in the south chapel, next to a flat marble slab depicting John Vernam and his wife Rose – this is often overlooked by comparison due to it 'only' dating to the late fifteenth century, although it is no less impressive. Vernam's son, also John (d. 1489), was four times rector. His alabaster effigy can be found screened from view in finely draped robes, although it is badly vandalised. The Vernam effigies are equally notable for the centuries of graffiti that adorn them.

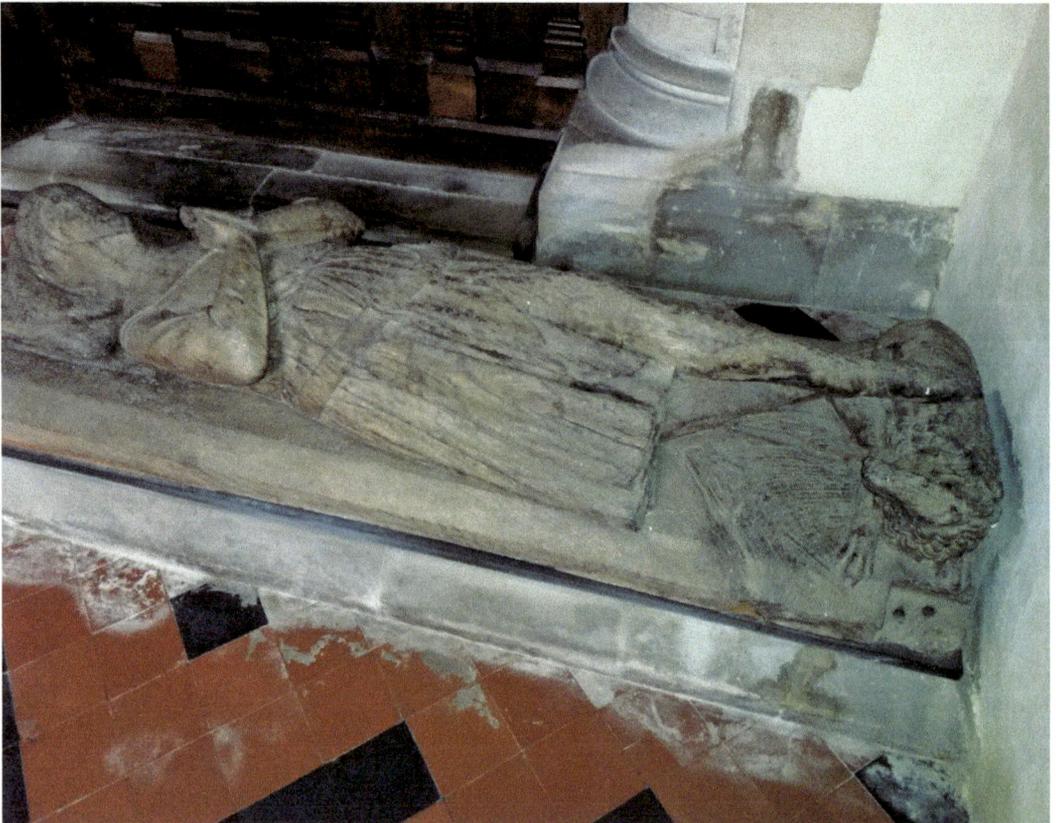

Ashwell's cross-legged effigy.

Tickencote's church also boasts a monumental wooden effigy of a fourteenth-century armoured knight. It is thought to represent Sir Rowland Daneys, who fought in France and was lord of the manor here. He also represented Rutland in the first Parliament.

Tinwell's Misplaced Rector

Tinwell sits on the north bank of the Welland, near Stamford. In the chancel of All Saints' Church is a memorial to a former rector, Rainer Herman, who died on 18 October 1668. The epitaph declares his origin was 'Tanger', which – given that he came from the Netherlands – more than likely means Angeren, a Dutch village.

However, strangely, for many years this was utterly misinterpreted as Tangier, in Morocco. One study, Brayley and Britton's *The Beauties of England and Wales* (1813), mused: 'How a native of Tangier in Barbary came to *Tynwell*, we could not ascertain; for though by his epitaph he seems to have been learned enough for a conjurer, yet he must have been the last (Herman) in the place, as we could find no person that knew anything about him.' The *Gentleman's Magazine* in 1803 speculated that, since Tangier had been given by the Portuguese as a dower to Princess Catherine upon her marriage to Charles II in 1662, then perhaps Herman had come to Tinwell from Morocco shortly after.

The memorials to Henry and all his wives.

One wonders what Rainer Herman would have made of this attempt to create a backstory for him based upon an incorrect assumption of his origins? He was in fact a prestigious fellow, locally renowned. Although Dutch by birth, he was educated at Westminster and Cambridge, ordained a deacon in 1641, was headmaster of Stamford School 1657–62 and then he was rector of Tinwell until his death.

DID YOU KNOW?
At St Peter's Church, Brooke, there is a memorial in the chancel floor to Henry Rawlins, who died in 1742 and 'was buried by his fifth wife' – the previous four having died between 1713 and 1722.

'How Beautiful She Fell'

The bridge over the River Chater, to the north-east of South Luffenham, is called Foster's Bridge after a man who hanged himself there. Around Christmas 1793 a group of travellers, headed by a 'king' called Edward Boswell, were camping on wasteland called The Follies near this bridge.

Boswell's daughter was reputedly a very beautiful young woman known as 'Rose the Princess'. That Christmas, however, she was dying of tuberculosis. Rose expired in early 1794 in a tent near the bridge after the clan had postponed moving onwards, and her heartbroken parents applied to have her body interred in St Mary's churchyard. There was an immediate clamour among parishioners in South Luffenham against this, although Revd G. Bateman eventually overruled all objections and allowed Rose to be buried in the south aisle of St Mary's Church.

Bateman performed the service before a large number of travellers. A short time later the parish officers were further surprised by the arrival, from London, of a handsome marble slab inscribed:

In memory of Rose Boswell, daughter of Edward and Sarah Boswell,
who died February 19, 1794, aged 17 years.
What grief can vent this loss, or praises tell;
A daughter meek, how good, how beautiful she fell

The slab was believed to have been purchased using contributions from many traveller clans wishing to show solidarity with 'the king'. It was placed over Rose's grave, where it remains to this day (although badly worn). The collective grief of the travelling community lived long in the memory of the parish: the *Stamford Mercury* reported in 1861 how eighty-two-year-old Francis Hippey, then still living in the village, witnessed the funeral.

Travellers also camped in the vicinity of Redhill Farm, south-west of Barrowden. In 1880 a violent altercation among them left one man dead, who was hastily buried under a hedge on the right side of the lane leading to ancient Turtle Bridge. According to the

Rose's name is still visible, although the slab is faded.

Rutland Local History Society in 1979, the matter later came to light but was never pursued. One wonders if the victim's skeleton is still there or whether their ghost still haunts the area – for decades now people's dogs are said to have become agitated at Turtle Bridge, barking at nothing and behaving oddly.

The Wagoner's Grave

In the grounds of St John the Baptist's Church, Bisbrooke, is an intriguing gravestone in memory of an early nineteenth-century parish wagoner, Nathaniel Clarke. It bears the inscription:

> Here lies the body of Nathaniel Clarke;
> Who never did no harm in light, or in the dark;
> But in his blessed horses he takes great delight;
> And often travelled with them by day and by night.

The wagoner's grave.

The stonemason's grave.

More remarkably, the limestone grave contains a (now faint) carved depiction of Clarke plying his trade – driving a wagon drawn by four horses. The carving also depicts the rustic scenery of the parish and implements of husbandry.

Clarke died on 27 January 1813, aged seventy-four, and is said to have been a whimsical fellow. The gravestone was erected by his son, Robert. The *Grantham Journal* reported in 1872 that, while Clarke's headstone had been 'religiously' preserved, the gravestone of eighty-one-year-old Mary Freeby Stevenson (3 yards away) had been deliberately mutilated on the vicar's instructions. Her epitaph had read: 'O death, acceptable is thy sentence unto the needy and unto her whose strength is now in the last age.' Apparently, the then vicar considered this verse 'unscriptural and senseless' and had it removed.

In the grounds of Holy Cross Church, Burley, there is another striking gravestone. This belongs to a stonemason who fell to his death in 1710 while working on the Winchilsea crest on the Burley mansion house. The tools of the mason's trade – brush, hammer and so on – are clearly visible despite the passing of over 300 years.

Robin Hood's Cave

Could it be that the semi-legendary outlaw and rebel Robin Hood was active in Rutland? There are certain traditions that insist he was. Approximately between Armley Wood and Barnsdale Creek, there could at one time be found a small medieval moated site with a stone cave feature bearing the name 'Robin Hood's Cave' – supposedly the outlaw's former retreat.

On 6 February 1916, during the First World War, the area thereabouts was the scene of a mock battle in preparation for an invasion, which ended with members of the Rutland Volunteer Training Corps 'besieged' in Robin Hood's Cave. The cave was filled in at the start of the Second World War by the War Agricultural Committee and is now lost forever – submerged beneath Rutland Water.

Written connections between Robin Hood and a place called Barnsdale go back to the very earliest sources: the Scottish chronicler and historian Andrew of Wyntoun refers to outlaws 'Litil Johun and Robert Hude' being active in Barnsdale over 100 years before his time. This was in his *Orygynale Chronicle*, a British historical work believed to have been scribed in the 1420s. There is an objection, however: Barnsdale in Rutland may have gone by the name 'Bernard's Hill' in Wyntoun's time rather than 'Barnsdale'.

The Tudor traveller Leland was shown a 'Robin Huddes cross', which at one time acted as a boundary marker between Lincolnshire and Rutland. This seems to have been in the district of Belmesthorpe. Neighbouring Northamptonshire is rich in traditions of Robin Hood, and perhaps most remarkably court records from the Law Society show that in 1354 a 'Robyn Hode' was gaoled at Rockingham Castle for trespassing in the royal forest of Rockingham.

There are vague traditions to this day that Robin Hood roamed the Forest of Leighfield, much of which is now an open landscape except for pockets of woodland. While researching *Just Rutland* in the early 1950s, J. & A. E. Stokes asked a tinker at Brooke what he made of the rumours and were told, 'Not being born them days, I couldn't say!'

The Tinwell Cave

In 1835, another mysterious cavern was discovered between Tinwell and Casterton, when a plough horse suddenly sank into a field owned by Mr Edward Pawlett. An inspection revealed the animal had fallen into a large square subterranean cavern supported by a central stone pillar, with stone sides and two bricked-up doorways at one end. It seems the cave was filled in and now lies beneath the A1 dual carriageway. (There is a sixteenth-century record of a 'Caves Mill' at Tinwell.)

7. Folklore and the Supernatural

The Langham Witches

A purge on witchcraft was enacted in the East Midlands around Christmas 1618 when Joan Flower, her two daughters and three others were accused of using curses and enchantments to remotely murder the two young sons of the Earl and Countess of Rutland. The two daughters, Margaret and Philippa, had been employed by the earl at Belvoir Castle but were dismissed. Both were hanged at Lincoln on 11 March 1619, while Mother Flower died choking on her own indignation as she was being transferred from Rutland to Lincoln Castle.

The story of 'the Witches of Belvoir' is a notorious one from that era of superstition. However, what is lesser known is that while their three co-accused were Leicestershire women, Mother Flower and her daughters lived in Langham. It was in their house that the women plotted their revenge using curses and spells. One ritual involved stealing one of little Lord Henry's gloves, which Margaret Flower found on the rushes in the nursery at Belvoir. The daughter presented it to her mother, who subsequently rubbed it on the back of her 'familiar' (i.e. imp, or spirit) named Rutterkin, bidding him 'height [fly] and goe and doe some hurt to Henry Lord Rosse'.

This spirit – Rutterkin – was reported at the time to have been in the likeness of a big cat, while the two daughters had their own familiars: Philippa's was a white rat that had suckled her, while Margaret had two spirits, one a white entity and the other black-spotted.

Although we know the fate of the three Flower women, it is not recorded what became of the other three who were implicated in the affair. One of these – Joan Willimot – seems to have been employed in Langham by a neighbour of the Flower women. She admitted that she had a spirit (called Pretty) given to her by her master, who she named as William Berry of Langham. After three years in Mr Berry's employ, he ordered Joan Willimot one day to open her mouth, whereupon (she stated) he blew into her face then told her he had just blown a fairy into her. Shortly thereafter Joan Willimot breathed out and there appeared on the ground in front of her a figure in the shape of a woman who demanded her soul. Joan claimed she had not used this supernatural entity for any malicious dealings, rather to help her neighbours. Was Joan Willimot suggesting her employer was the Devil? Either way, she was a principal witness against the Flower women.

One is also mildly curious as to what became of Rutterkin, who can be assumed to have been merely a feral sinister-looking cat. With the disappearance of its mistresses, perhaps it prowled Langham, causing great fear whenever it was spotted – until it was ultimately chased off or, worse, symbolically killed.

The seriousness with which the threat was taken at the time was clearly all too genuine. Francis Manners, 6th Earl of Rutland, died in 1632 and was buried in St Mary's Church, Bottesford. Beside his tomb are effigies of his two daintily dressed little boys, who the inscription confirms 'dyed in their infancy by wicked practice and sorcerye'.

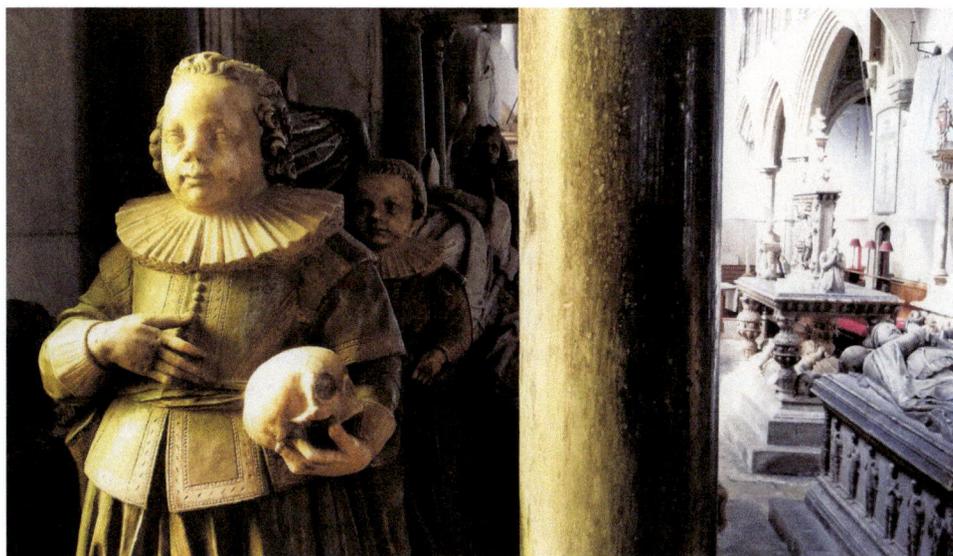

Effigies at Bottesford, Leicestershire, of the two boys killed by Langham's 'witches'.

As an aside, in Langham's church there is an incised alabaster slab to John Clerke, who died in 1532, and his two wives, Jone and Anys. This remarkably engraved memorial would have been familiar to the Langham witches – even then, it was already ancient.

At Burley House, wags are supposed to have kidnapped a gossip's cat called Rutterkin, killed it and dressed the house dwarf, Jeffrey Hudson, in its skin. Thus disguised Jeffrey spoke to a woman, when she offered him cheese thinking he was a genuine cat; cries of 'witchcraft!' rang through Burley House until the 'joke' was revealed. One imagines the prank was in some way inspired by memories of the Langham witches.

DID YOU KNOW?
Bees were thought to have been very sensitive creatures. There is a report in the late nineteenth century of a beekeeper's wife in Geeston knocking on the hive and informing the bees their master had died. The bees hummed in reply, which was taken as a sign they would not desert the hive.

The Stoke Dry Witch

The small chamber – or parvis - over Stoke Dry's church porch is accessed by a thin spiral staircase with a low ceiling. It is here that an old tale, impossible to ignore, insists a local witch was locked away. This witch notoriously ended up imprisoned in the parvis on the orders of the rector of the time, who allowed her to starve to death. The *Rutland Magazine* noted in 1906: 'The usual story follows, as a matter of course, that her ghost still

haunts the church.' I understand that in the late 1980s there was a rumour that the witch's insane, hysterical cackling rang through the church following funerals, and was actually heard (allegedly) by a group of visitors in 1988. However, these included a now largely discredited psychic, and a sign at the foot of the parvis declares the legend 'cannot be supported'. No date for the witch's imprisonment is suggested.

According to *The Villages of Rutland* (Vol. I, Part II), at one time another witch would rush out of her house near Snelston and cling onto cartwheels as horses made their way up Galley Hill, between Caldecott and Uppingham. (Snelston is another deserted medieval village, which was marked as a settlement on seventeenth-, eighteenth- and some nineteenth-century county maps, although it was often referred to as 'Snelston ruins'.) Some accounts suggest this old crone lived in a tree and would leap onto the carts. She appears to have been regarded as some kind of supernatural entity, for by the early twentieth century she was said to have been 'charmed down for a hundred year'.

Although the two stories appear distinct, their proximity makes one wonder if they somehow concerned the same 'witch'. That is to say, perhaps the original subject was an old woman who lived at Snelston, who in the days of Puritanism ended up in the parvis, where she was allowed to die. Legends that she haunted both Snelston and Stoke Dry would perhaps naturally develop after that.

Stoke Dry's church parvis – the witch's cell?

The Seaton Road Ghost

In the days before the Seaton Viaduct, Seaton Road meandered through the countryside to Harringworth unimpeded, and it was here a remarkable supernatural encounter occurred.

On 16 October 1757, Samuel Cave, a young Caldecott farmer, was thrown into Oakham Gaol after being accused of murdering his servant girl in an orchard – she was allegedly pregnant by him. The girl's name was Ruth Salmon and particulars of the crime are unclear, although in November Cave was reported to be 'raving mad'. Cave's mother was also arrested on suspicion of involvement in the crime, apparently on the evidence of a manservant.

Cave and his mother were cleared of the murder at the next assizes. Not long after, extraordinary allegations surfaced that a manservant called Peter (possibly the same one) had encountered the victim's ghost on the Seaton road on 12 March 1758. At first he had seen a light drift past him, which he took for a will-o'-the-wisp, but then it called his name. When he looked closely he could see the dead girl's face within the light. The ghost implored him to go to her father and tell him that Mrs Cave – the accused's mother – knew who the murderers were.

The manservant was perhaps not active enough, though, since this phenomenon appeared before him again on 19 March and begged him to make it known Samuel Cave and his brother were the murderers, before vanishing. The next day the manservant took this information to Justice Medlicot of Cottingham, but nothing appears to have happened beyond this.

This odd encounter turned up in the private correspondence of a local man to his brother dated 23 March 1758, which then featured in several newspapers. The writer mentioned he had interviewed the manservant: 'The man verily believes the thing himself.'

DID YOU KNOW?
Local and national newspapers reported in September 1979 how mystified residents of Exton were declaring that a band of monkeys (possibly as many as five) were staging nocturnal raids on their greenhouses and dustbins. Where they came from was never properly ascertained and they were last seen swinging through trees at Stamford.

The Uppingham Hoard

In June 1764 the newspapers reported an odd story from Uppingham. Apparently, the eighteen-year-old daughter of Cornelius Nutt saw a ghost on several occasions that told her there was something valuable hidden in the house. Various searches turned up nothing, until the girl directed a workman to dig up a particular floor stone, which revealed a black pot filled with 200 pieces of ancient silver coin. Mr Nutt decided to take them to London to sell, after being advised they were very valuable and being offered a guinea apiece for them.

The ghost itself is not described; the papers that reported the incident were wary, in case it turned out to be a fabricated phenomenon, like the then notorious Cock Lane ghost.

The story is oddly reminiscent of a modern one. In Uppingham the principal pub is the Falcon Hotel, a towering sixteenth-century former coaching inn. The Falcon dominates the centre of the historic market town. At one time the inn had an entrance that allowed coaches through to the rear, but this has now been turned into the reception, snack bar and sitting room. The place's old well also still exists – under the floor near the bar. In the nineteenth century the inn hosted a county court that sat regularly to try minor offenders from Uppingham and the surrounding villages, and the excise office was also situated here.

According to local lore a highwayman who had just robbed a coach on Galley Hill stopped his horse briefly at the Falcon while he was being chased, where he threw his stolen money into the old well. Being captured and hanged on the gallows for his crime, he was never able to return to the Falcon to recover his booty; therefore, it is said that his ghost now makes the journey in spectral form.

The highwayman's ghost is referred to in the *Stamford and Rutland Mercury* (6 August 1976), but when the authors contacted the current owners of the Falcon in June 2014 it transpired they did not know of the ghost that supposedly haunted their premises. So perhaps this means the phantom highwayman has finally located his loot?

The Falcon Hotel.

Galley Hill supposedly earned its name from the days when a gallows stood on the slope by the roadside there. Nearby, Gipsy Hollow Lane is said to have been a notorious place for murders in the days of highway robbery; and for generations the entire stretch of road bore an eerie reputation for being haunted. This only subsided in the 20th century, when horse and carts began to be replaced by motor cars.

A Superstitious Burial at Oakham

On 10 January 1794 the *Stamford Mercury* reported that the previous December John Pillen of Oakham had cut his own throat, languishing for ten days before dying. A coroner's inquest brought in a verdict of suicide, 'in consequence of which, his remains were, on Monday last, buried near the highway, with a stake drove in the grave'.

The burial of suicides at crossroads was a normal practice at the time and was intended to disorientate the deceased's spirit, lest it rise from the grave and return to haunt the living. The stake seems to have been double insurance against Mr Pillen's revenant rising from the earth, vampire-like, to terrorise the town. One wonders if he bore some sort of reputation in Oakham at the time...

The Edith Weston Poltergeist

It was widely reported in December 1896 how great numbers of curious people had flocked from surrounding districts to Edith Weston, following allegations that the house occupied by Mr and Mrs Gray was troubled by a poltergeist. For a full week during the run up to Christmas the premises was invaded by 'something' that loudly and repeatedly knocked incessantly at the doors and windows, night and day. Hundreds of people heard the noises, for which there appeared no logical explanation. The property's owner – Mr Braithwaite of Edith Weston Hall – even visited, only to profess himself utterly baffled. Gray was employed as a farm bailiff by Mr Braithwaite.

At its height, the entire village could hear thunderous knocking. Doctors, clergymen, the police and schoolmasters were all employed to try and find out the reason, but it proved beyond them. It was even reported at the time that forceful raps were heard against a newly varnished door, which when checked revealed no marks or other signs of how this could have occurred. On another occasion thumping could be heard from the inside of the cellar, which when unlocked proved to be occupied by nothing more remarkable than a sack of potatoes. Strangest of all, on one occasion two investigators stood either side of the front door, but each could hear hammering between them as though something was striking the other side.

A fifteen-year-old servant girl was blamed by some parishioners for causing the noises. As they continued in her absence, however, others began to suspect she was in league with the Devil and had admitted him into the house. Other theories were that the noises were down to a ghost with important information to impart, trying to get the attention of the living.

The upheaval began to badly affect Mrs Gray's health, and Mr Braithwaite began to consider pulling the house down. But during the Christmas holidays the noises subsided and although every effort was made to solve the mystery, it was in vain. Nonetheless, the servant girl may well have been the conduit; a London investigator reported how the

noises sometimes began in the kitchen after the girl had gone in, when she habitually shouted merrily to 'it', 'Here I am, come on, you!'

The location of the house isn't exactly clear, although one visitor at the time suggested it was at the angular corner in the village, a two-storey affair with two red doors fronting out onto the street and another red-doored house attached to it.

The Ghosts of Stocken Hall

At the end of Stocken Hall Road, nestled between three patches of woodland – Little Haw Wood to the east, Stretton Wood to the south and the much larger Morkery Wood to the immediate north – can be found Stocken Hall itself. In its former life a Jacobean manor house built during the reign of James I, the hall has been added to over the years and is now a Grade II-listed building. In the twentieth century the hall stood derelict for some time until it was converted into an open prison farm in the 1950s, before this became superseded by the nearby HMP Stocken. In its present incarnation the old hall is said to be plagued by tormented souls, and those residing in the elegant apartments situated there now may not be aware they are living in one of the most haunted places in Rutland.

According to J. & A. E. Stokes's *Just Rutland* (1953) the hall had three ghosts, the most commonly seen being a 'little white pup' like a wire-haired terrier, which left an intense chill as it slinked past witnesses before disappearing. Around 1900, people even held doors open for it regularly, before finding it had utterly vanished. The other two ghosts – mentioned in the *Rutland Magazine & County Historical Record* in 1904 – are more disturbing.

In the early 1900s numerous people are said to have witnessed the figure of a young woman, dressed in black, although with some white about her, in a corridor at the hall. If seen from a distance, she quickly disappeared away down the corridor; if encountered at close proximity, she would always have her head bowed, and as a consequence her face was never observed. A local legend held that she was the wraith of a girl strangled to death in one of the attics in the seventeenth century. The ghost was last seen on 18 January 1903.

Thirdly, on the afternoon of 22 December 1897, the three elder daughters of the hall's occupier were 'crossing the park towards Clipsham' when all saw a semi-transparent figure, dressed in a brown smock with a white cap pulled over its face, hanging from the branches of an old oak tree. The apparition – which was seen roughly where the prison now sits – suddenly vanished as they approached it. The oak was around eighty years old at the time with a curious large mound behind it. There was a rumour at the time a sheep stealer had been lynched somewhere in the neighbourhood at an uncertain date. Perhaps the ghostly hanging figure was in some way connected to John Eaton and Anne Baker, who were executed at Oakham on 3 August 1801 for sheep theft. They lived at Clipsham and their victim (Mr Wyles) at Stretton, so the pieces are there, although the sighting still doesn't make much sense.

Stocken Hall is now private property and off-limits to ghost hunters. One of its eighteenth-century tenants was General Grosvenor, whose favourite horse, Black Butcher, fell dead underneath him near the Stone Ride in Morkery Wood, and was buried on the spot. Grosvenor erected a small marker over the animal, surmounted by an obelisk

and carved on one side with a relief portrait of the horse and on the other with a poem celebrating his qualities. The inscription on it is now very weathered, but once read:

Within old Morcary Wood you hear the sound
Of Lowther's voice encouraging the hounds.
Pass ye not heedless by this pile of stones
For underneath lie honest Butcher's bones.
Black was his colour yet [his] nature fair,
Where ere the hounds went Butcher would be there
'Tis graven to be a tribute to his worth,
Better hunter ne'er stretched leathern girth.

I have heard it said that Black Butcher's ghost haunts the obelisk, which is just on the Rutland-Lincolnshire border. Stone Ride is a favourite place for dog walkers, and around four years ago I was told by one of them that their pet regularly 'acted up' near the obelisk, pricking its ears up, barking and straining as though it could sense another animal in the trees there. Apparently, 'other dog owners have reported the same thing.' Oddly, the horse's ghost, which is also said to appear galloping up to the hall, is sometimes said to be white. This is perhaps something to do with the transparency of the alleged apparition.

Black Butcher's obelisk.

The Phantom Panther of Rutland

Anecdotes concerning a mysterious panther-like animal (or animals) in the county go back years. The local media occasionally reports surprising encounters with this large beast, such as the experience of two cyclists in October 2016: they spotted a large, dark-coloured, long-tailed feline-like creature running like a cheetah through a field of long grass between Teigh and Market Overton. It appeared to be hunting down a pheasant, and the pair watched it for two or three minutes. Reports of this nature go back to at least the 1990s, and the animal has earned the nickname 'the Rutland Panther'. In 2010 it was even reported that motion-sensor cameras were being set up in rural Rutland to try and photograph it. This followed a motorist's sighting of a black cat-like creature bigger than an Alsatian that walked in front of his car while he was passing Greetham Valley Golf Club in the direction of the A1. The discovery of savagely mutilated livestock in southern Rutland in 2008 has also been blamed on this animal.

Apparently, around 2014 the proprietor of the Rutland Falconry & Owl Centre, where eight leopards were kept, was contacted by a concerned woman who asked him whether one of his leopards had escaped. After checking and ascertaining all was OK, he asked her why she thought such a thing. The woman explained that it was because 'three lads' in the bar at Barnsdale Lodge had been overheard saying that they had spotted 'a large, brown cat' crossing the road somewhere in the vicinity, it's form caught in their car's headlights. When the falconry centre's owner hastened to the lodge and talked to the men, he found them still in the bar and was told the same. In explanation, he suggested a black panther's coat might appear brown when captured in the unnatural light of a headlamp; furthermore, he believed it entirely possible such an animal could sustain itself in the wild.

The proprietor told this story to a friend of mine visiting the centre, who in turn passed it on to me in August 2014. And, in all honesty, the opinion of a man who keeps eight leopards – and knows his stuff – ought to count for something when evaluating this long-running mystery.

Aerial Phenomena

Remarkable phenomena have been witnessed on occasion in the sky above Rutland. Around 11 a.m. on 22 October 1721, for instance, two bright mock suns, an arc of a rainbow inverted, and a halo were observed above Lyndon – there had been an aurora borealis the night before. This was in addition to the actual sun, which was also visible. Stranger still, the phenomenon reappeared the next day, and again on the 26th. The preceding September, there had been another aurora borealis seen from Rutland, presenting truly unaccountable movements in the sky.

On 15 September 1749 a strange meteor, resembling some kind of water spout, tore through the sky above Rutland, which was described at the time:

> I saw it pass from Pilton over Lyndon lordship, like a smoky black cloud, with bright breaks; an odd whirling motion, and a roaring noise, like a distant wind, or a great flock of sheep galloping along on hard ground. It was divided into two parts all the way it went, and though there was no wind, moved apace. As it went by a quarter of a mile east from me, I saw some straws fall from it [it had evidently carried away hay bales] and a part,

like an inverted cone of rain, reached down to the ground. Some who were milking, said it came all round them like a thick mist, whirling and parting, and, when that was past, a strong wind for a very little while, though it was calm both before and after. It then passed off between Edith Weston and Hambleton, but how much further I do not know.

On 20 November 1864 the residents of Uppingham heard a strange sky-borne noise 'like the discharge of canons in the distance'. The cause was believed to have been a detonating meteor off the coast of Lincolnshire, meaning that the noise must have been tremendously loud to have been heard so far inland. Nearer our own time, the *Rutland Times* reported in 2008 how two people, driving towards Uppingham, had seen a UFO hovering over the town. The object had a large dome shape on its top with lights that resembled an erupting volcano; it stayed in the sky for about a minute and then disappeared. The sighting occurred at 6.15 p.m. in October that year.

DID YOU KNOW?
An urban legend from Uppingham claims that in the early 1900s a group of schoolboys were found to be playing football with a human head on Red Hill; due to recent flooding, human remains had been washed out of the nearby cemetery, where the boys discovered them.

Miscellaneous Haunted Places
Rutland boasts a rich ghostly heritage, and we conclude this exploration of the smallest county's secrets with a round-up of its ghostly locations. One of the oldest stories comes from Braunston. A compiler of supernatural anecdotes, Richard Baxter was told in 1665 that the house of the rector there (Mr Beecham) was plagued by a poltergeist that floated a tobacco pipe between shelves in a particular room and even once plonked a Bible onto the lap of a visiting rector, Beecham's father-in-law.

One ghoulish event was widely reported in 1886 when a group of Uppingham schoolboys gained admittance through a window into the ruinous Glaston Hall, locally said to be haunted by the appearance of ghosts. While trying to locate the haunted room the boys discovered the body of a man hanging from a lintel, later identified as a sixty-nine-year-old groom who had been missing for a week. The boys fled in terror, and one may imagine that local gossip later blamed some supernatural presence for luring the unfortunate man to his death in the old building. The hall had seventeenth-century origins, but it was subsequently taken down and the materials used at Glaston House.

In late Victorian times villagers in Braunston were reputedly seeing a spectral lady who carried a candle before her. She walked into the manor house's nursery from a pond in the grounds. Locally, she was supposed to be the wraith of a former nanny at the house, who drowned herself in the pond. The then owner, Mr Hanbury, decided around 1895 to have the pond filled in and the site exorcised.

In 1900 Great Casterton learned of the death of its rector, Revd Edward Sellman, who shot himself in the library of the rectory. An inquest heard he was addicted to morphine and mired in a scandal. Some say he never recovered from the death of his six-year-old daughter Cecilia following an accident in 1896 (a brass plaque to whom can be seen in the church). The shockwave his suicide sent through the parish was immense, and eighty years later the Rutland Local History Society recorded the belief that Sellman tolled the church bell once before shooting himself at 11 p.m. His ghost was later blamed for a frequent 'bumping' noise heard on the rectory's top landing, which prompted a subsequent vicar to perform an exorcism. This apparently stopped the noises. Sellman's grave, with a stone cross laid on it (rather than standing), can be found in the churchyard within sight of the Old Rectory.

The *Rutland Magazine* reported in 1904 that Teigh Hill was haunted by a ghostly woman who carried her own head tucked under her arm. There was also a legend that the apparition of 'Wild Lord Lonsdale', with a coach and four horses, had been witnessed at night racing along Love Lane, between Market Overton and Edmondthorpe.

A windmill used to be situated in the extreme west of Preston, although it was pulled down in 1926. This is perhaps just as well, for it denied a reputed 'headless horseman' a hiding place. This entity was locally said to leap the hedge bordering the road to Ridlington, terrifying travellers so often that the spot actually earned the name Ghost Hollow.

Sellman's grave, with the Old Rectory in the background.

In 1937 the *Nottingham Evening Post* reported that 'old ladies' inhabiting Lyddington's Bede House (when it was used as an almshouse) blamed 'a ghostly visitant' for driving away all the elderly men who also resided there. Previous supernatural events had occurred at the Bede House. Around 1883 the warden's son had followed a man through the cloisters, up the stairs and into the Old Refectory, where the figure promptly disappeared in the middle of the room. The following day, the warden's son learned his brother had been killed on the railway.

In Cottesmore, the Dowager Countess of Lonsdale is said to have brought a donkey from Egypt back to Cottesmore Hall, which she named Pharaoh and rode around the grounds. After its death the donkey was believed to haunt the hall's yard, according to *The Villages of Rutland* (Vol. 1, Part I). The countess died at the hall in 1917 and thereafter its fortunes began to decline dramatically, including a fire in 1926 that almost destroyed it. It was finally pulled down in the 1970s to make way for a housing estate, although the hall's outbuildings are still visible on Mill Lane.

Morcott Manor House, dated 1687, has the story of a duel fought by two brothers during which blood was shed on an upstairs floor. However hard the floor was scrubbed, the bloodstains could not be removed, and this phenomenon continued until the offending floorboards were eventually taken up. The fight was supposedly over a 'Lady Betty', and I have been told that after the floorboards were removed, Betty herself started haunting

The remnant portions of Cottesmore Hall stand opposite the fifteenth-century tithe barn, with its eye-catching gable-end dovecote.

the house. She was, apparently, seen on multiple occasions in the 1940s – a small woman wearing a rustling crinoline dress.

North Luffenham Hall is haunted by the ghost of Gunpowder Plotter Everard Digby, who was sighted in 1957, according to the reputable ghost hunter Harry Ludlam (*The Mummy of Birchen Bower*, 1966). The hall is the former Digby manor house, and in the parlour there are said to be freezing cold pockets of air even when the rest of the room is at normal temperature.

According to *The Villages of Rutland* (Vol. I, Part II), strange noises were heard from within Manton's Old Hall in 1942 when the seventeenth-century building was empty. A local legend told of a servant girl having been strangled at the hall many generations earlier, whose ghost the noises were put down to. And a phantom passenger allegedly killed in a catastrophic coach crash many years earlier haunted Stocks Hill, being witnessed in 1973.

One who was educated at Oakham School was Matthew Manning, the bestselling author, healer and world-famous psychic. Manning attended the school in 1970, when he was fifteen, and the disturbing poltergeist outbreaks that plagued the place during his residence there are still remembered to this day. Legend has it that staff at the school made him perform a ritualistic spellcasting in the dormitory each night to allay the paranormal phenomena.

One of the strangest legends the authors learned of concerned a hedge situated in a hollow along a track called Pear Tree Lane, Thistleton, which would bow down whenever someone walked past it. This was told in the 1970s to a former resident of South Witham, who explained to me in 2007: 'Many people said it bowed so low it almost touched the ground, and creaked and rustled as it did so, like it was talking. What caused it, I couldn't say. I think there was supposed to be some kind of spirit in it, but I think it was a very old story even then.'

Recently attracting the attention of ghost hunters was the sprawling complex of the former HM Prison Ashwell, which announced its closure in 2011 following a destructive riot two years previously. There are stories of objects moving by themselves, cries emanating from the old cells and the shadows of invisible people appearing against the walls. One reported phenomenon is the distressed wailing of a woman, which might be an echo of when the site was home to the US 82nd Airborne Division during the war since no female prisoners were incarcerated at HMP Ashwell. It is now the site of Oakham Enterprise Park.

And this is just a selection of Rutland's ghostly anecdotes. Even when it comes to the supernatural, it seems there is *multum in parvo* hidden here. There is so much else generally that could also have been included within this work, which space forbade; such as the county's historic associations with the brewing industry, for example. Suffice to say that there are further opportunities for discovery, for those interested in Rutland's classic landscape, picturesque towns, time-locked villages and hidden treasures.

Manton's Old Hall, looking onto Stocks Hill.

View from the Empingham Dam side of Rutland Water.

Acknowledgements

Photographs of Oakham gallows and Oakham Castle horseshoes are used with permission of Rutland County Council (www.rutland.gov.uk/museum). Many thanks to Margaret Stacey of the Uppingham Local History Study Group for advising on the ghost at the Falcon, Uppingham. The group's website can be found at www.uppinghamhistory.org.uk. Also thanks to James at the Falcon for assistance on the same; Christine Smith for anecdotes picked up regarding the 'Rutland Panther'; Robert Clayton, head of Culture & Registration at Rutland County Council, for help with information on Oakham Castle; Charlotte Ridpath, Oakham Castle activity manager, for the same – for more information on this jewel in Oakham's crown please see www.oakhamcastle.org.

Thanks also to Jill Kimber of the Rutland Local History and Record Society (RLHRS) for her valuable help with source material. This largely concerns one source, *The Villages of Rutland* (Vol. I, Part I and II), a 1979 collection of anecdotes, folklore and reminiscences from mid-twentieth-century Rutland. Anyone wishing to delve deeper into Rutland's history should visit their website: www.rutlandhistory.org. Thanks to Spiegl Press, Stamford, for allowing me to draw upon the same source. See www.spieglpress.com for more info on this local printing business.

Thank you to Revd Charlotte Osborn at All Saints' Church, Oakham, for help seeking out church carvings, and Lorraine Cornwell, collections manager at Rutland County Museum, Catmose Street, Oakham, LE15 6HW – see www.rutlandcountymuseum.org. uk for more on their fascinating collection. Finally, if the sharp-eyed happen to pick out any small inaccuracies in the data, please excuse the author. All that can be said by way of defence is that all sources utilised were considered reliable, including the numerous contributions from county residents who helpfully provided snippets of local lore and pointers towards further information.